D0515719

SAN FRANCISCO IN THE SIXTIES

SAN FRANCISCO IN THE SIXTIES

EDITED BY
GEORGE PERRY

Picture Editor: Suzanne Hodgart
Art Director: Grant Scott

First published in Great Britain in 2001 by
PAVILION BOOKS LIMITED
London House, Great Eastern Wharf
Parkgate Road, London SW11 4NQ
www.pavilionbooks.co.uk

A CIP catalogue record for this book is available from the British Library.

ISBN 1 86205 431 2

Colour reproduction by Bright Arts, Hong Kong
Printed and bound in Spain by Graficromo

10 9 8 7 6 5 4 3 2 1

This book can be ordered direct from the publisher. Please contact
the Marketing Department. But try your bookshop first.

Opposite: Flag power on the street

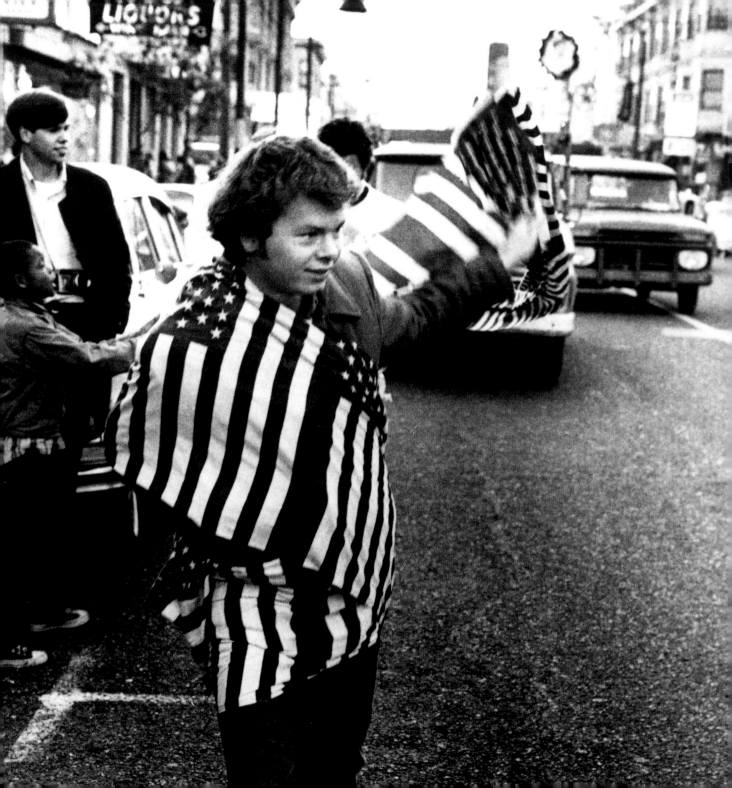

O n 22 December 1969 a familiar sound echoed across San Francisco Bay. The foghorn on Alcatraz Island – site of the infamous Federal prison that closed in 1962 and which had lately been invaded by a band of Indians announcing that they were reclaiming their heritage – was pumping out its cautionary message. However, there was no fog. A cable short circuit was the cause, and the engineers sent to rectify the trouble found that if they shut the apparatus down there would be a serious danger to shipping should one of San Francisco's frequent dense fogs roll in. Not until New Year's Eve was the mournful noise finally quelled and a peaceful silence restored. The cacophony was perhaps a fitting metaphor on which to end a turbulent decade.

Alcatraz, an evil island, marring the splendour of San Francisco like a black tooth on the face of a beautiful woman, was the place where Al Capone and scores of America's worst, most dangerous felons had been incarcerated. In its time it exerted a terrible fascination on visitors to the easy-going city, its very own off-shore Chateau d'If interrupting the magnificent view of the Golden Gate Bridge. Tourists would eagerly gaze at the island through coin-operated telescopes on Fisherman's Wharf, hoping to catch a glimpse of white-garbed inmates who, in turn, were said to be driven to near insanity from frustration when tinkling feminine laughter and soft music wafted across the water on summer evenings from yacht club parties. Officially nobody ever escaped from Alcatraz, but shortly before the closure three prisoners had got away, and were presumed drowned, although the bodies were never found.

The hilly city on the Bay has always been regarded as hedonistic and exotic by most of middle America. It owed its expansion from a humble fishing village initially to the 49ers, the hardy Gold Rush pioneers in the middle of the nineteenth century, who could only get there by sailing around the Horn or making the overland crossing through the dangerous Panama isthmus. Some even tried getting through the Rockies, the hardest journey of all. The proximity of whaling and lumber in Alaska, coupled with a remoteness from the East Coast, giving an almost greater kinship with China and Japan across the Pacific, and the constant influx of mariners, liberated after months at sea and eager to blow their wages in a night, gave San Francisco its reputation as a bawdy, anything-goes town. Its nineteenth-century history was a bumpy boom-and-bust ride. For some the 1906 earthquake and the disastrous fire that followed were seen as a divine punishment for an excessive lifestyle. Then the devastated city buckled to and rebuilt itself to the most exacting earthquake safety code hitherto seen in America.

The indulgent reputation lingered. The dives of the Barbary Coast gave way to North Beach's International Settlement, a block-long stretch of bordellos and dubious nightspots. In 1955 Lawrence Ferlinghetti established

the City Lights bookstore on Columbus Avenue in the neighbourhood, the natural rallying point for the so-called 'beat' poets, led by Allen Ginsburg, transplanted from New York. The *San Francisco Chronicle's* witty columnist Herb Caen came up with one of his many happy neologisms to describe them, the term 'beatnik'.

In early 1962 another admirer from New York, the Italian-American singer Tony Bennett, recorded his evocative hit 'I Left My Heart in San Francisco', providing the city with its most famous anthem. The line about 'little cable cars, reaching halfway to the stars' had a particular resonance because local pressures had forced the municipality to reprieve three of the original eight lines that were being removed in the early Post-War years, so that to this day tourists can ride the oldest and most exciting form of urban street transportation to be found in the United States, even if it can offer a speed no faster than nine and a half miles per hour, the same as that prevailing in the 1880s.

The awareness of environmental and ecological damage in the name of progress could have been fostered in San Francisco. The central city is compact, located at the head of a narrow peninsula separating the large natural harbour from the Pacific Ocean. As it is surrounded by water on three sides, expansion was only possible through landfill or by building to the south, and formerly separate communities such as Daly City, San Bruno, Pacifica and even Burlingame were absorbed into the conurbation. Houses crept up the steep slopes of Twin Peaks, the steep high point closest to downtown San Francisco, threatening the fine view from Market Street, the city's main street. A hard-fought battle brought any further development in that direction to a close. Another campaign, to protect the impressive ancient forests close to the city, such as Muir Woods, across the Golden Gate in Marin County, was entered into, with 'Save the Redwoods' as its battle cry.

The worst despoliation of city vistas was caused in the late 1950s by the construction of the double-decked Embarcadero Freeway which coiled around the waterfront and separated the Ferry Building from Market Street, and the convenience for traffic was perceived by many as of far less significance than the environmental impact. One of the city's more acute earthquakes occurred in 1989 and, although it was not of the severity of the 1906 disaster, it was serious enough to cause the Freeway's elevated section to topple, and the opportunity was taken to remove it altogether, one of the first instances anywhere of a large mid-century urban road system being torn down.

On a more positive note, at Fisherman's Wharf the big redbrick Ghirardelli chocolate factory had outlived its purpose, but instead of being demolished, the old buildings were rehabilitated to form a pleasant collection of shops, art galleries and restaurants, setting an example of urban regeneration for cities in the rest of the world to follow.

The attractions of San Francisco, with its lively art, music and literary life, and a climate that was tolerant in both a social and a meteorological sense, were a magnet for young dropouts, many of whom had no further wish from life than to laze in the sun and indulge in the open-minded drugs scene. As the waves of the new age of permissiveness swept across the world in the 1960s

San Francisco acquired a Nirvana-like reputation. The epicentre of activity was not the usual beatnik hangout, North Beach, now a site on tourist itineraries, but the district around the intersection of Haight and Ashbury Streets, to the south-west of the downtown area. The irrepressible Herb Caen was soon calling the locality 'Hashbury', a reference to the most basic of substances that was circulating on the streets there.

What was emerging was the hippie movement, a particular phenomenon of the 1960s, based on protest and disaffection with established political order, capitalism, militarism, consumerism and the bourgeois life in general. The ethos of hippiedom was that of a genuine counter-culture with the intention of turning its back on cities in order that communities could become self-sufficient, existing on whatever they could grow on the land. Too much reliance on illegal marijuana crops distorted such noble aims, and in Hashbury stoned young people, dropouts and draft dodgers lolled in the block-wide grass strip attached to Golden Gate Park, known as the Panhandle. It was a time for gurus. Timothy Leary arrived from the east to preach on the liberating powers of LSD. Ken Kesey, hitherto a novelist, invented Happenings, Love-ins, Be-ins, as the hippie festivals were called. The Diggers, a specially formed assembly of volunteers, became the hippie social welfare organization, providing soup kitchens, free food and thrift clothing.

Hippie attire was eccentric and eclectic, much of it recycled. Girls favoured mini-dresses and Victorian velvet, flared trousers and caftans, while men wore jeans and fringed leather jackets, with the hair long and often embellished by moustaches and beards. Beads, charms, bangles, ethnic jewellery often oriental in origin, were unisex. The climax of hippie strength was the so-called Summer of Love of 1967 when 'Flower Power' blossomed as a counter-force against police oppression, racism and, above all, the insanity of the Vietnam war and its arsenal of horror. The invasion of Hashbury by hard drugs dealers, and the onset of related crime led the Diggers in October of that year to stage a mock funeral for the hippie movement, including the interment of a clay coffin in Buena Vista Park.

There was a San Franciscan explosion of graphics in posters and publications that owed its distinctive visual style to the hallucogenic effects of LSD, and the term 'psychedelic', meaning mind-expanding, was coined to describe these forms of art and music. Poster lettering was squashed and distorted, and often coupled with line images in flowing designs. Publications such as *The Oracle*, *BAM* and the eventually mainstream *Rolling Stone* were founded, and underground comics had a world-wide effect, with Robert Crumb and Gilbert Shelton among the emergent artists.

Music, as Shakespeare would have it, is the food of love, and San Francisco developed its own special sound. Old auditoriums and ballrooms were saved from the wreckers' ball to become the Winterland, the Avalon and particularly the entrepreneurial Bill Graham's famous Fillmore. Bands such as the long-lived Grateful Dead, with Jerry Garcia as its lead singer, and Marty Balin's group, Jefferson Airplane, with Grace Slick, originated in San Francisco. There were many others: Santana, Country Joe and the Fish, Moby Grape, and Big Brother and the Holding Company which made a star of

the tragic Janis Joplin. In the pop world Scott McKenzie had an enormous hit with his lyric 'If You Are going to San Francisco Be Sure to Wear Some Flowers in Your Hair'. Timothy Leary and many thousands duly obliged.

The photogenic qualities of San Francisco have never been neglected by Hollywood, and film-makers throughout the decade exploited its fine settings. Two British directors were responsible for the most memorable, using the thriller as their genre. For sequences in *Point Blank* John Boorman took advantage of the vacated prison island of Alcatraz. Prior to this, films with an Alcatraz setting would have been mocked up on a sound stage, but now the empty buildings awaited the location scouts.

Another film demonstrated an even greater capability to inaugurate a great screen cliché. When Steve McQueen gunned his Ford Mustang up to top speed on the steep inclines to the north of Market Street that contribute to San Francisco's appeal, in the celebrated ten-minute chase sequence in *Bullitt*, directed by Peter Yates, the effect was electric. Nobody had dared drive at such speeds before on these vertiginous streets. The discovery was made that the effect of the plateaus at the intersections, a level pause in the sharp downward passage, was to make the car airborne, causing it to surmount the crest like a ski jumper. Many films since have copied the *Bullitt* chase, but none has generated the same surprise. Another enduring movie image of San Francisco in the 1960s was that of Dustin Hoffman in *The Graduate* tearing across the Oakland Bridge in a tiny red Alfa-Romeo sports car on his way to see his beloved at Berkeley. Purists have noted that he was in fact going the wrong way as the bridge is double-decked, with inbound traffic on the top level.

Much of the ferment of anti-Vietnam protest originated on the University of California at Berkeley campus where the free speech movement evolved in 1964, following the 'freedom summer'. It was the springboard for an escalating series of confrontations that would lead to the explosive 'People's Park' riots of 1968 when 2,000 National Guardsmen were called in to face massed ranks of hippies and student radicals. Berkeley was one of many centres of unrest around the world and the university authorities became increasingly beleaguered and helpless as anarchy prevailed. Race was a serious combustible element for the Berkeley flashpoint. There had been Civil Rights protests in San Francisco in the early 1960s, and the militant Black Panther movement was conceived by Huey Newton in Oakland.

San Francisco weathered the stormy 1960s in characteristic style. It may even have come through a better place.

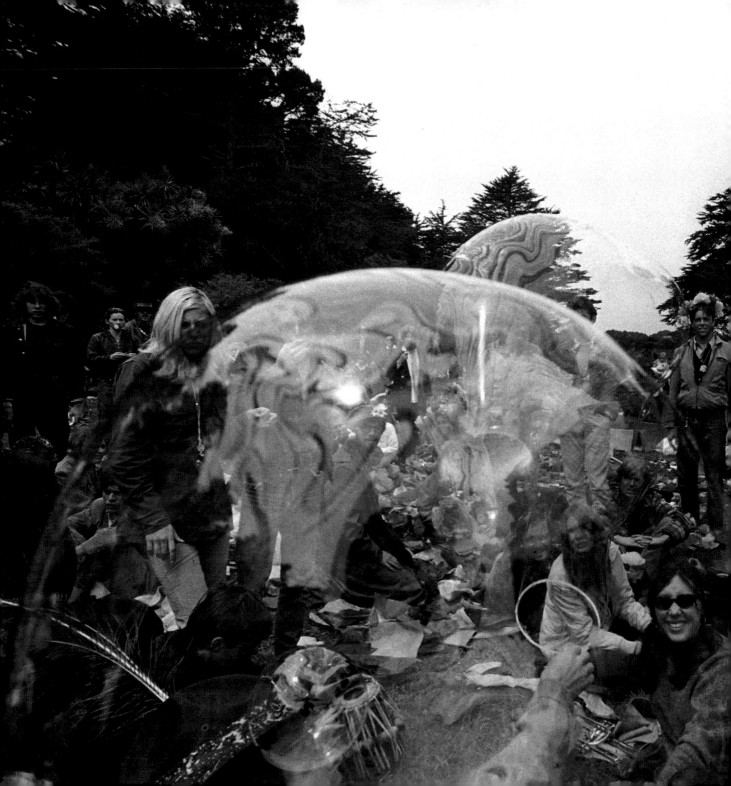

Blowing bubbles

Seekers of love

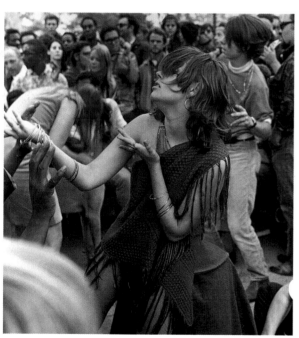

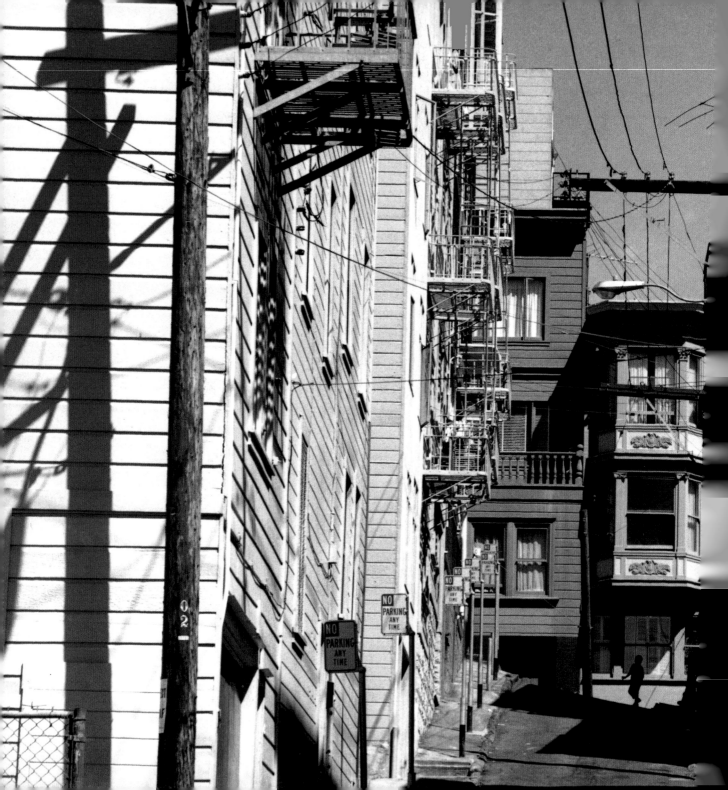

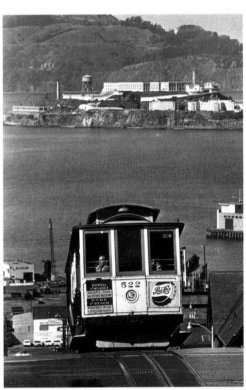

Above: Little cable cars

Left: North Beach

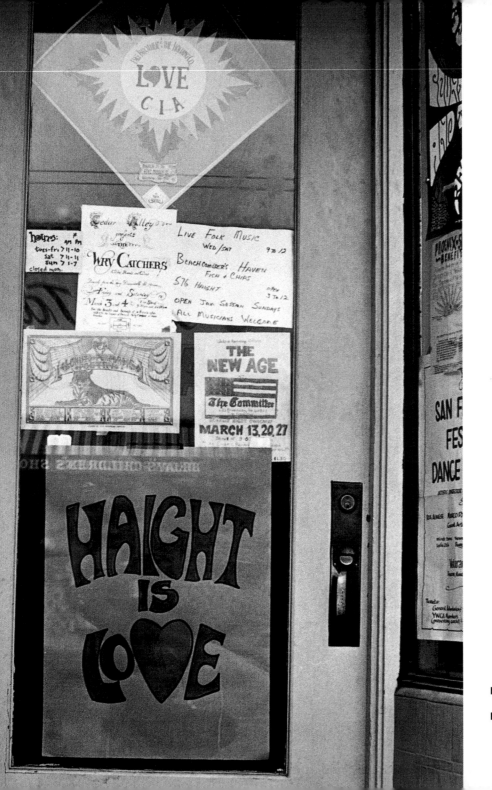

Left: Passing the word

Right: Getting the message

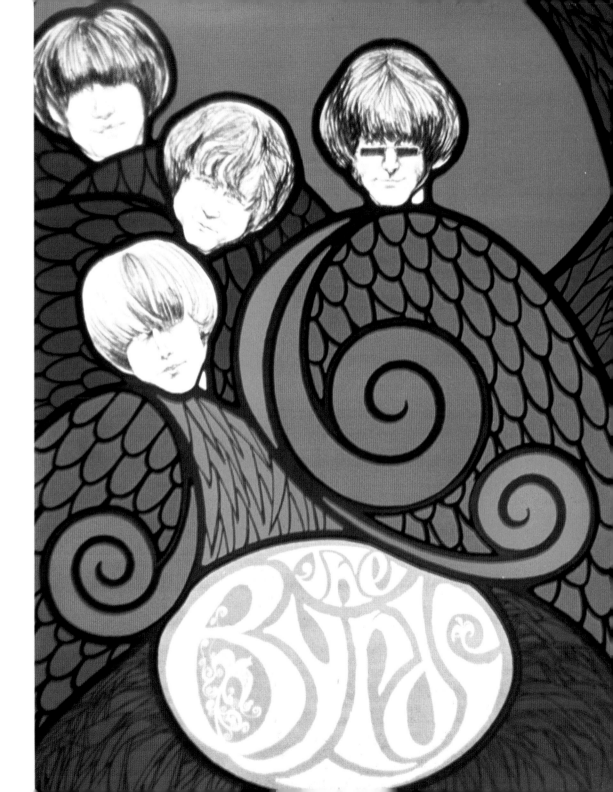

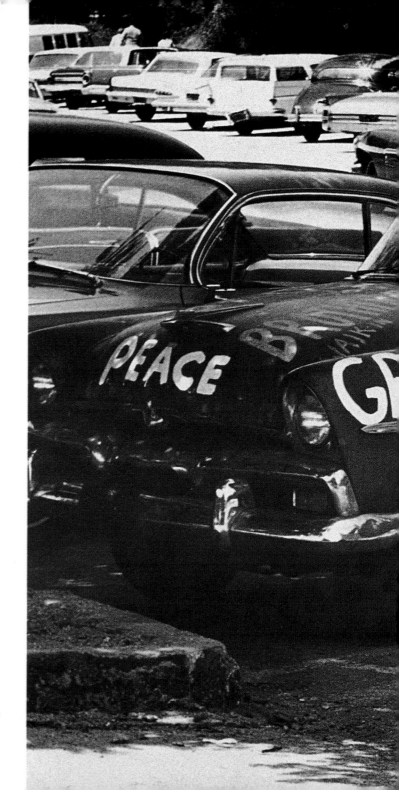

Green power

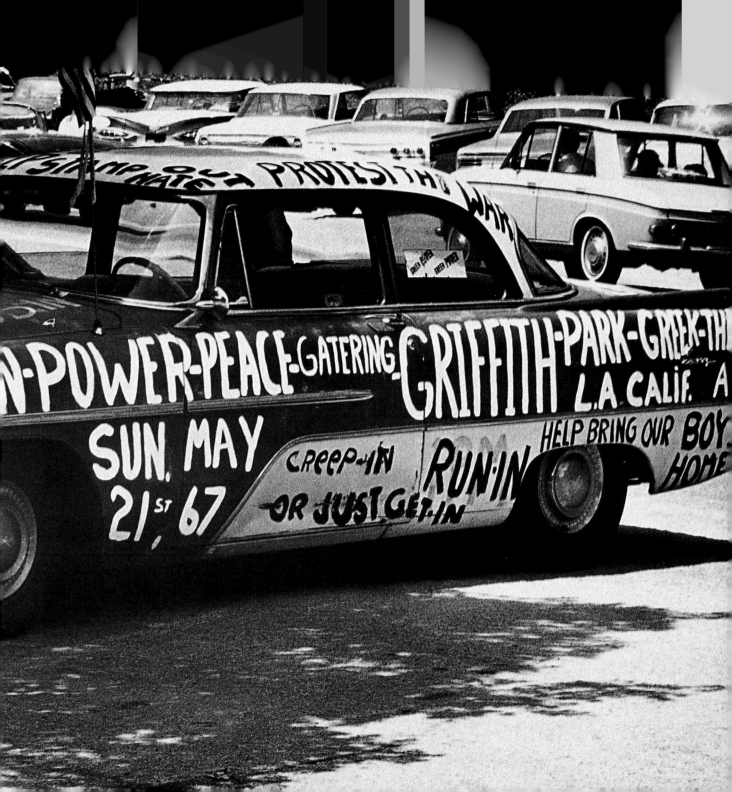

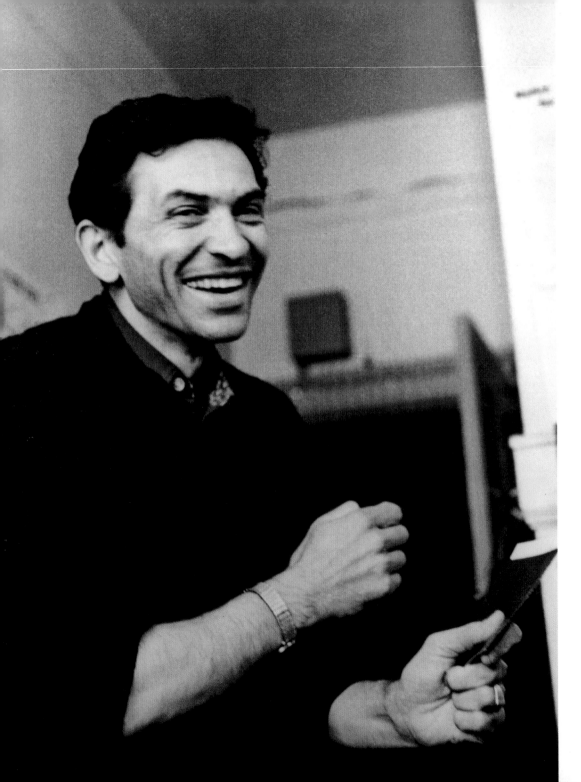

Left: Bill Graham,
impresario

Right: Bill Graham
sets the stage

Overleaf: Inside the
Fillmore

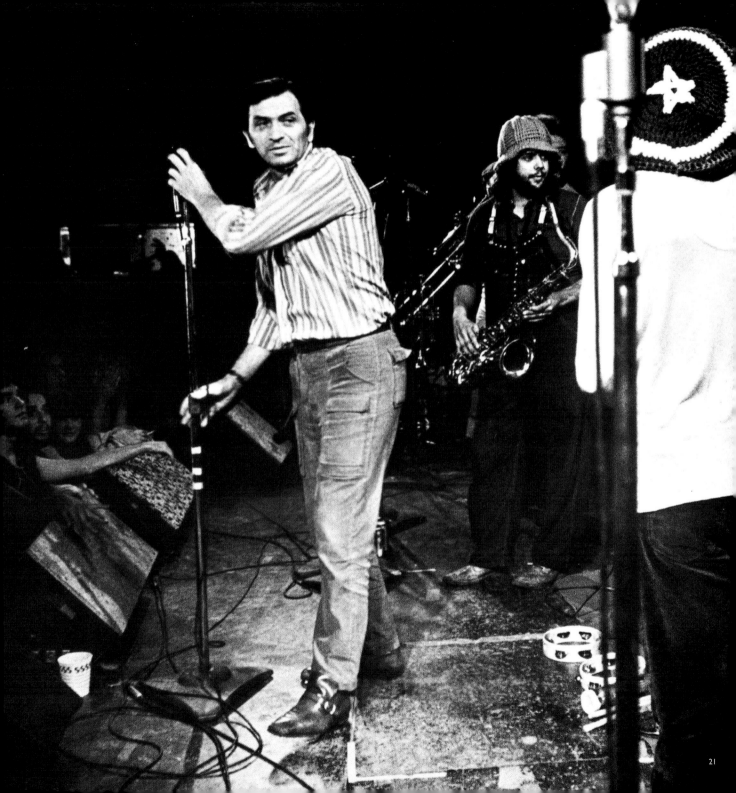

21

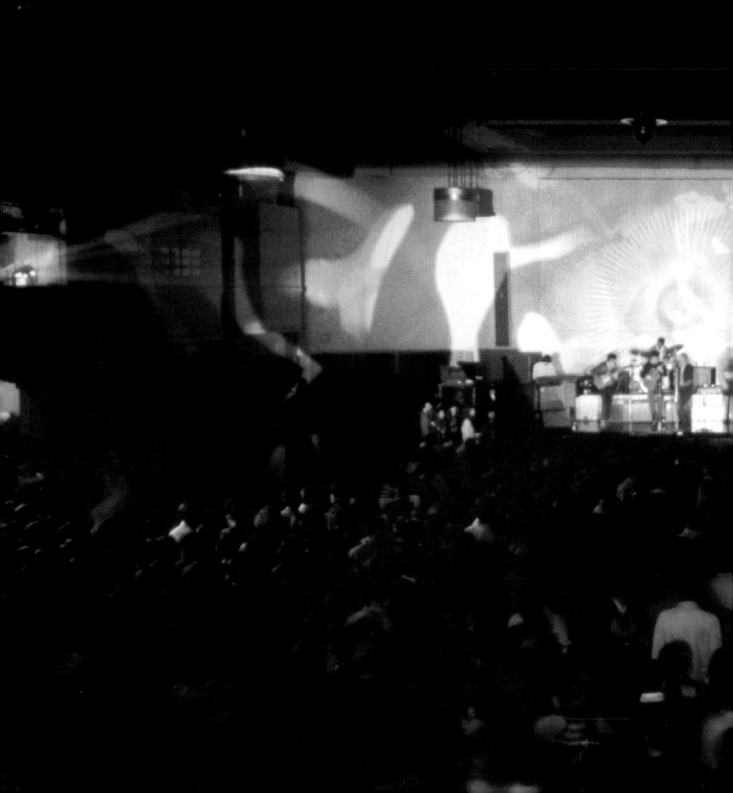

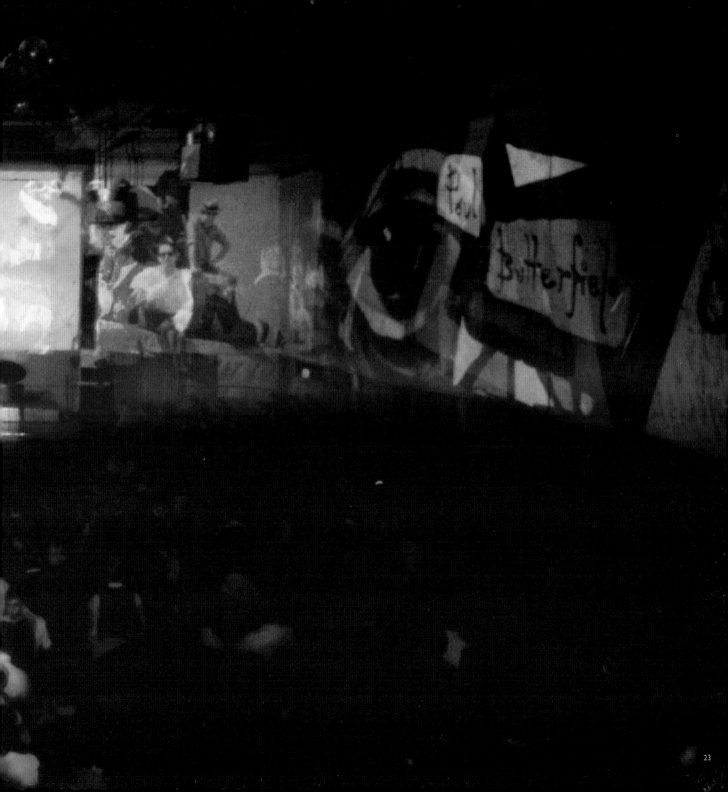

Below: The Grateful Dead – plain loco

Right: Grateful Dead star Jerry Garcia salutes

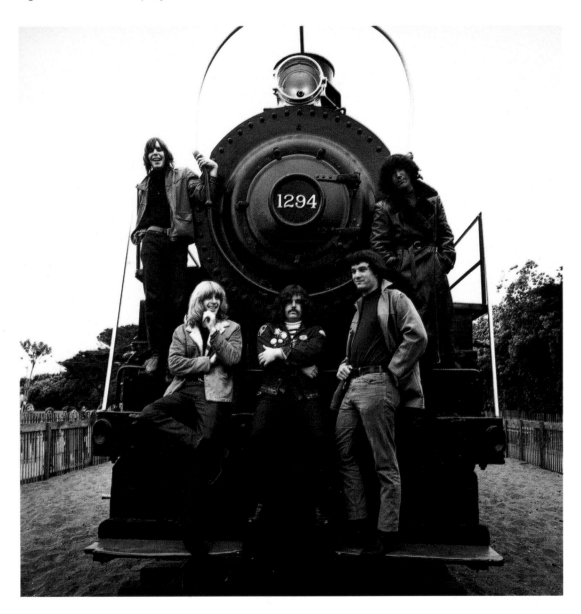

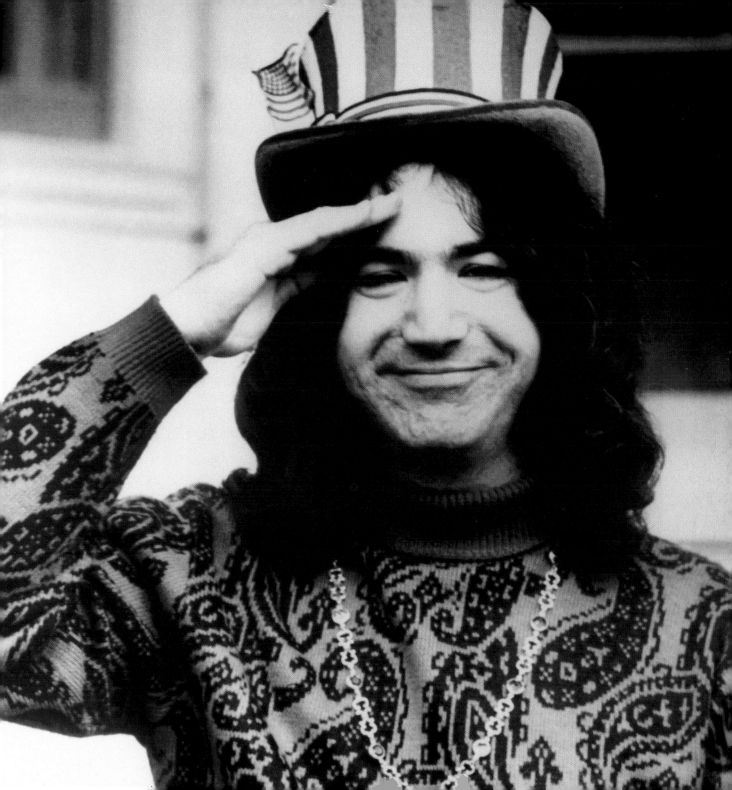

Below: World-famous corner

Right: Grooving along

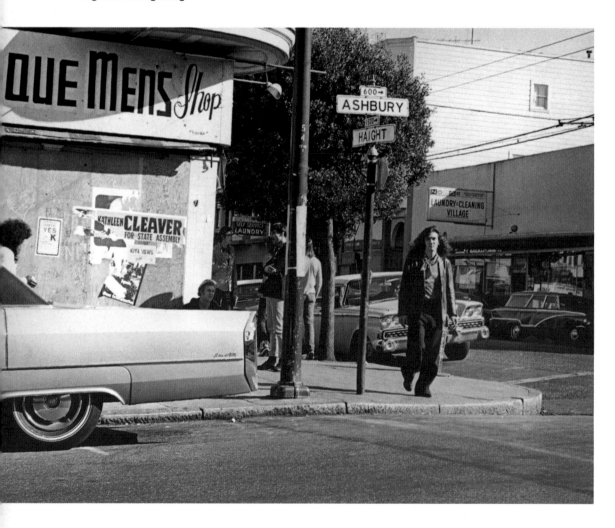

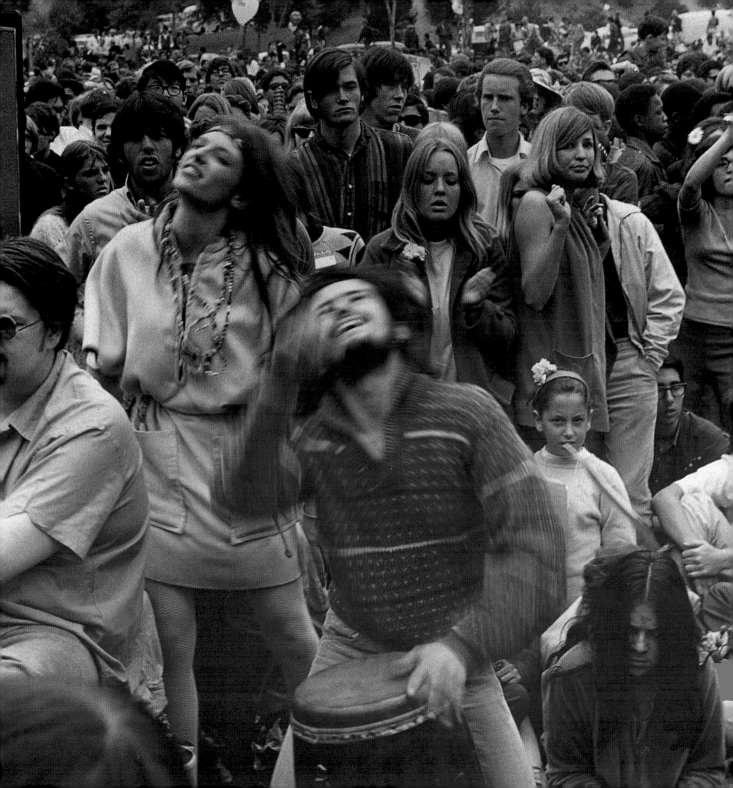

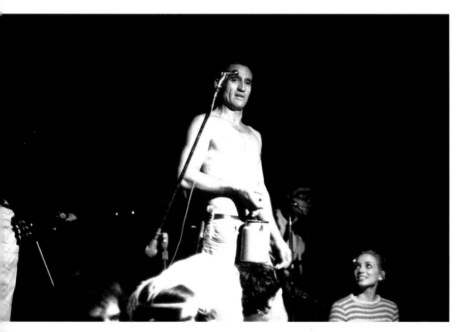

Above: Merry Prankster proffers acid

Right: Writer Tom Wolfe with the Grateful Dead.

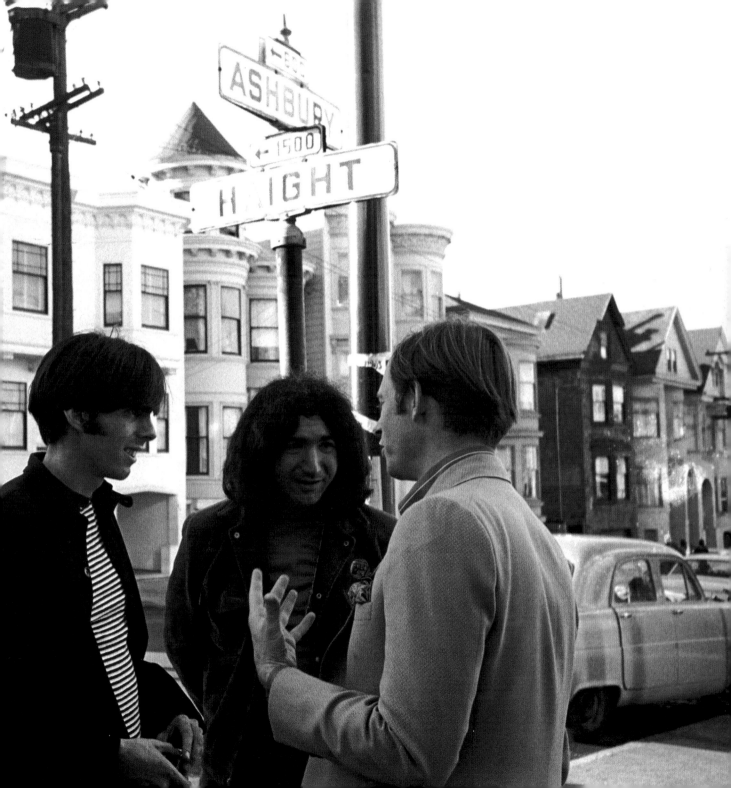

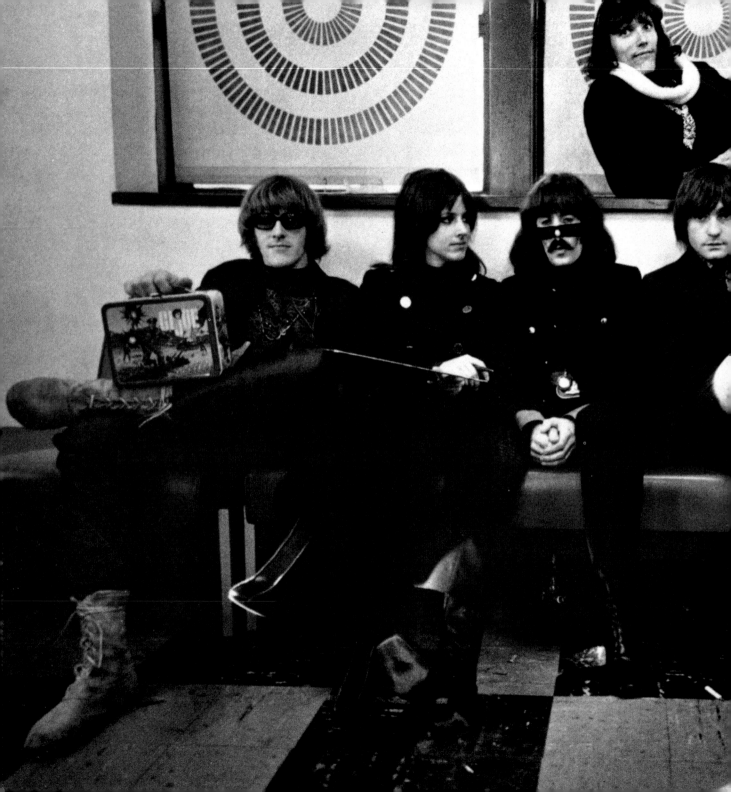

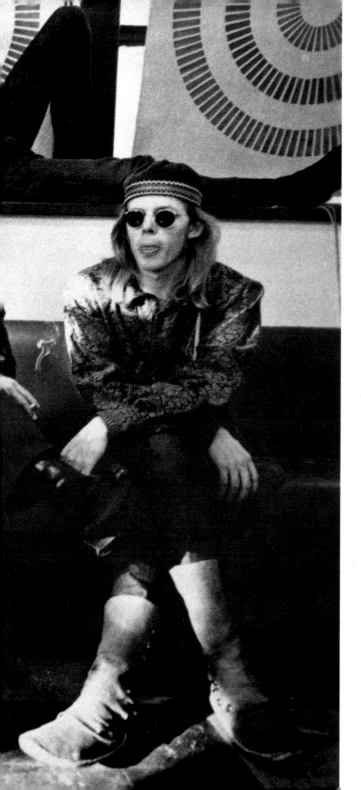

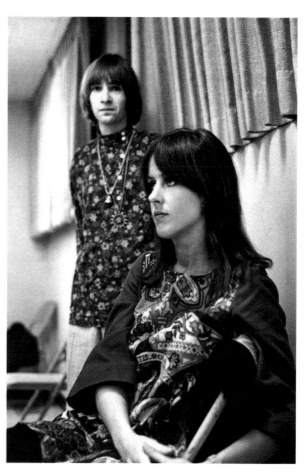

Above: The Airplane's vocalist, Grace Slick

Left: The Airplane lands

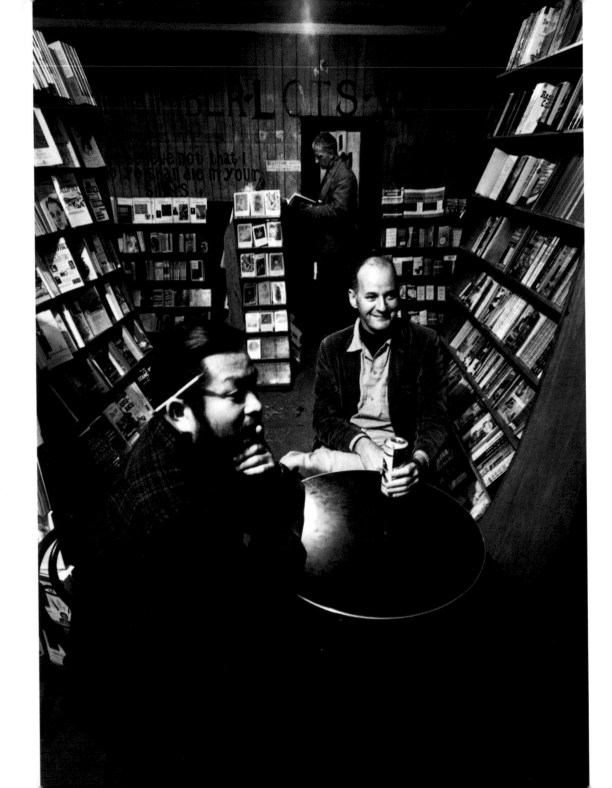

Left: City Lights bookshop

Below: Author Ken Kesey and his beads

Overleaf: Be-in in Golden Gate Park

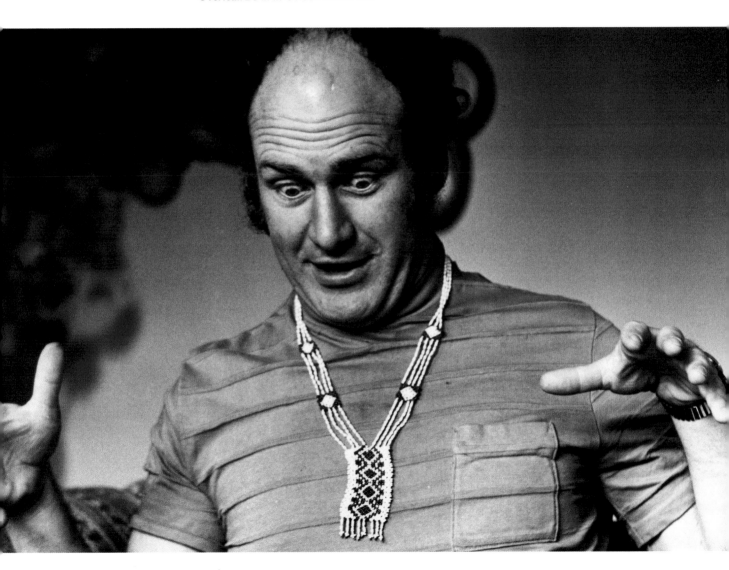

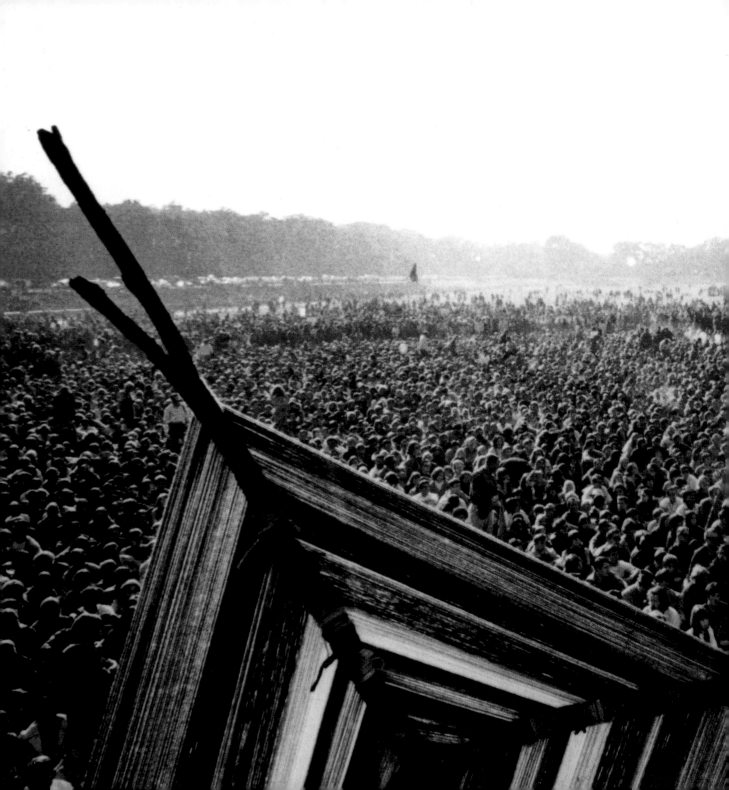

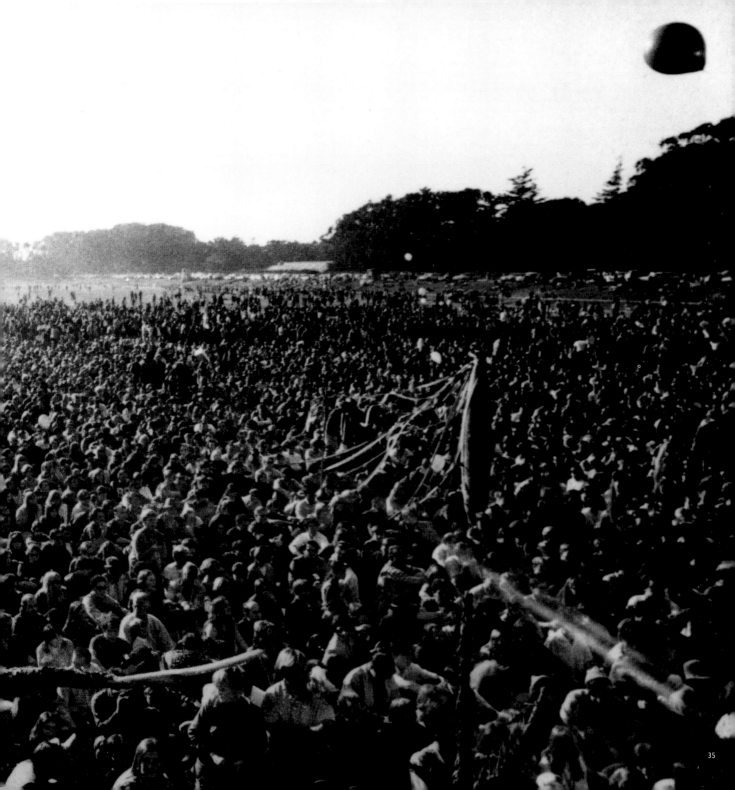

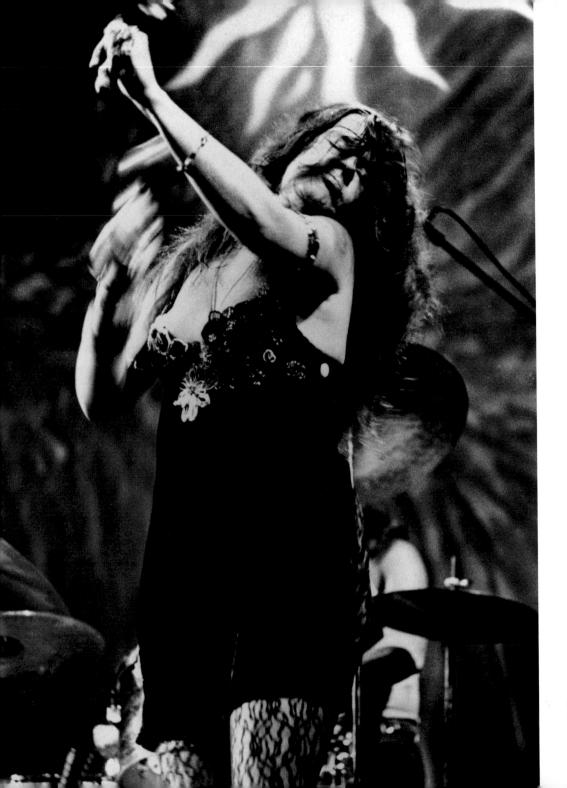

Singer Janis Joplin,
tragic diva

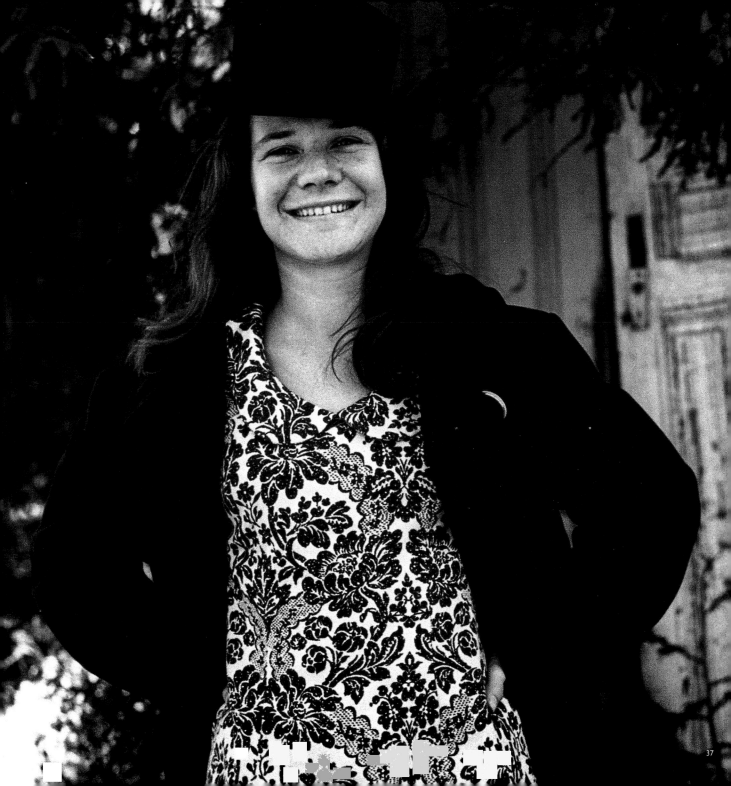

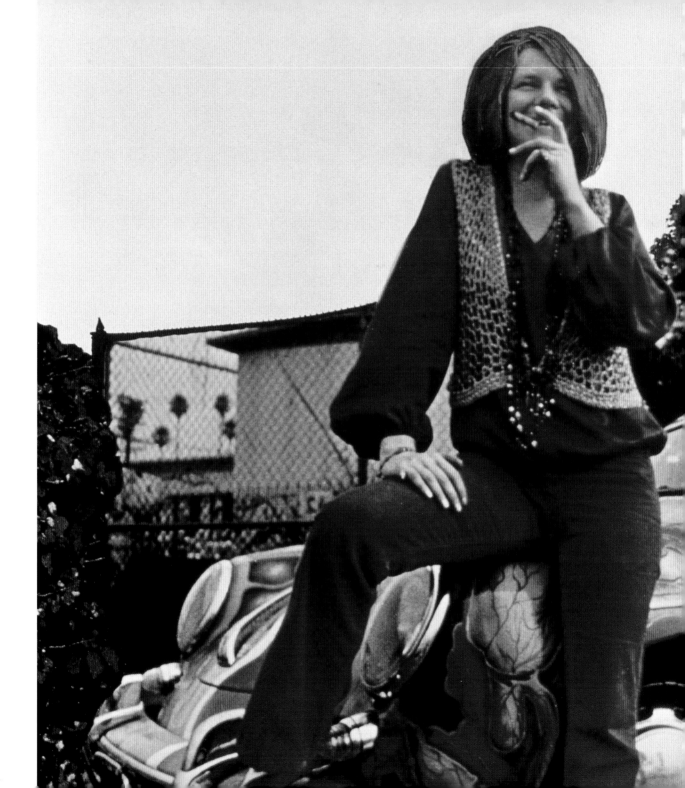

Janis and Porsche

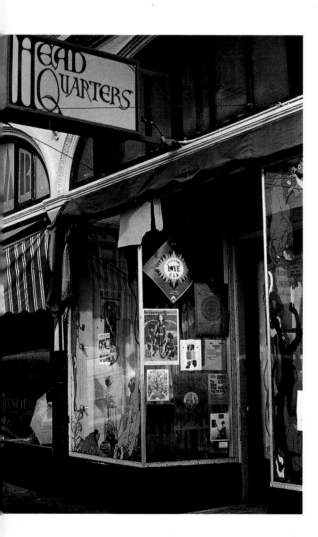

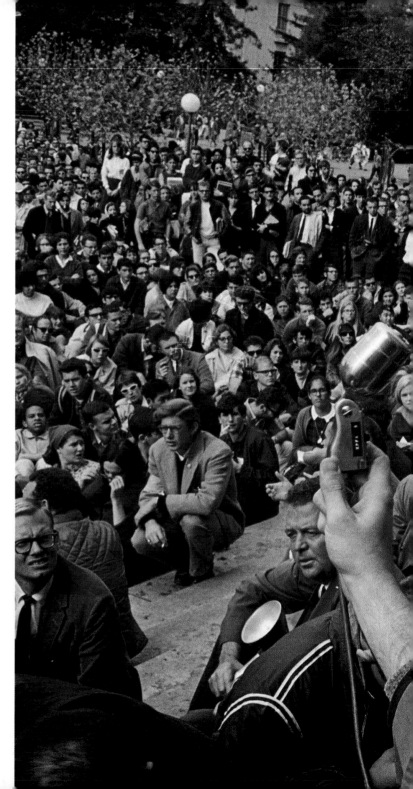

Above: Haight shopfront

Right: Folk singer Joan Baez entertains

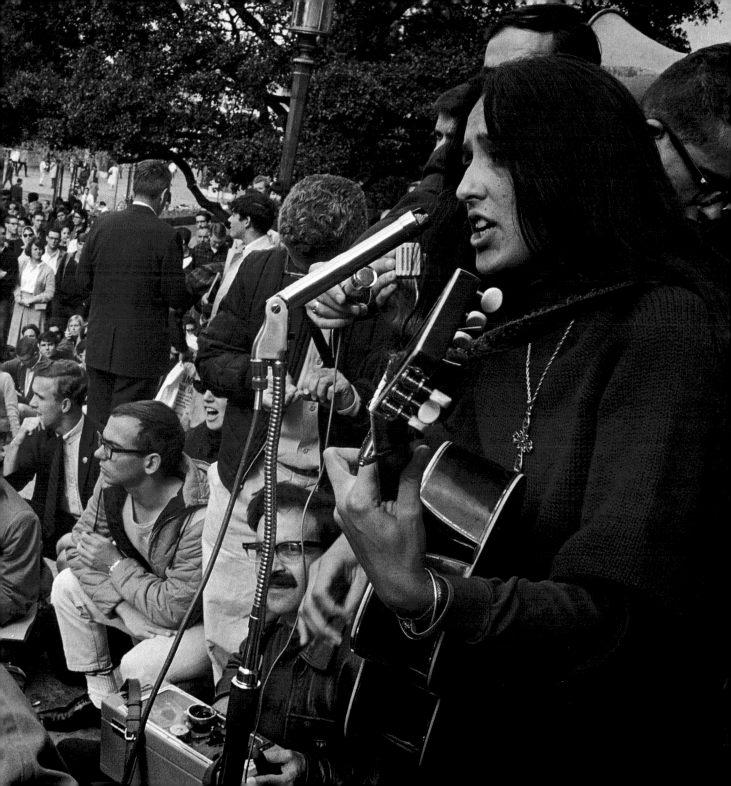

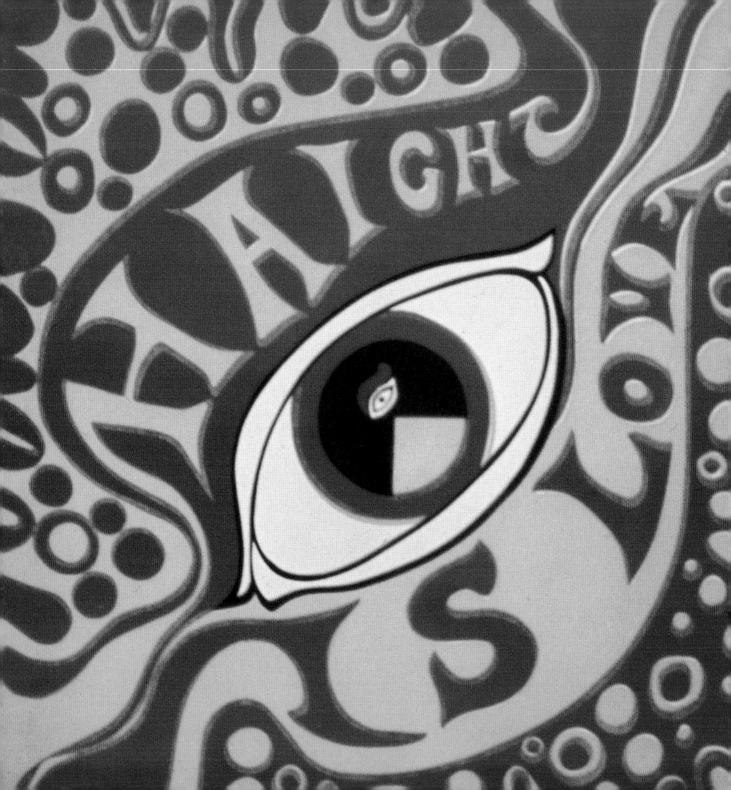

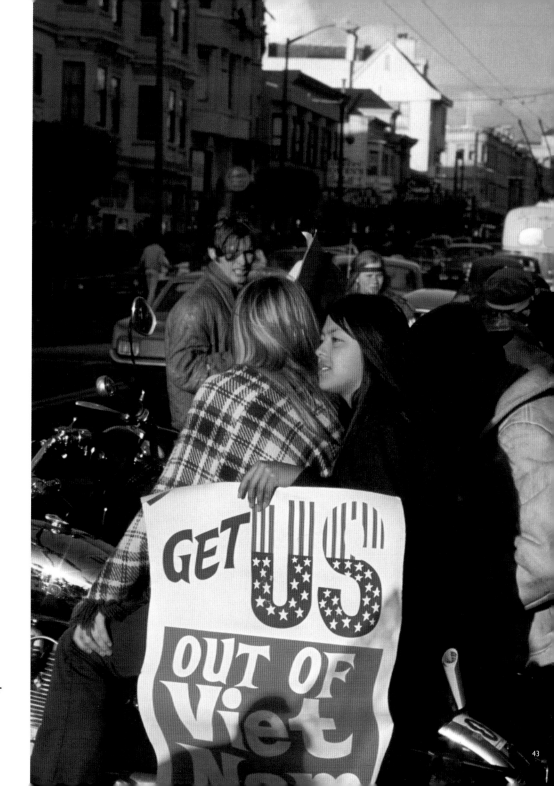

Left: A San Francisco
summer of love poster

Right Love, not war

43

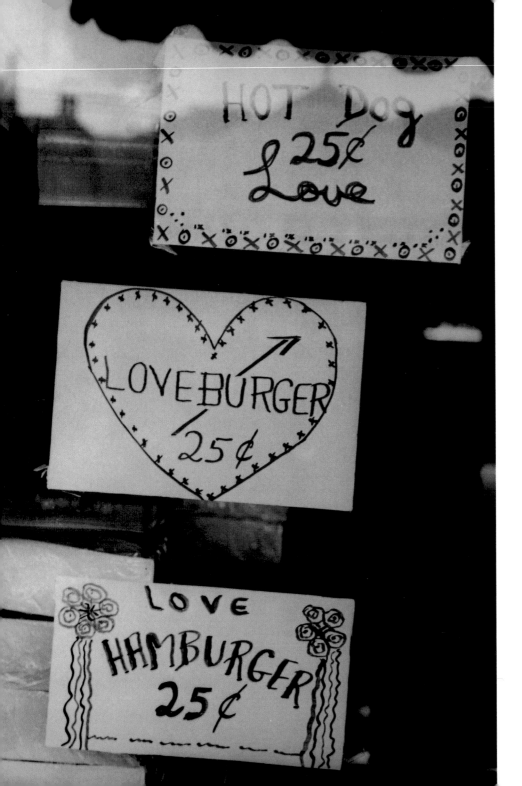

Left: 'Love' fast food

Right: Home life on Haight

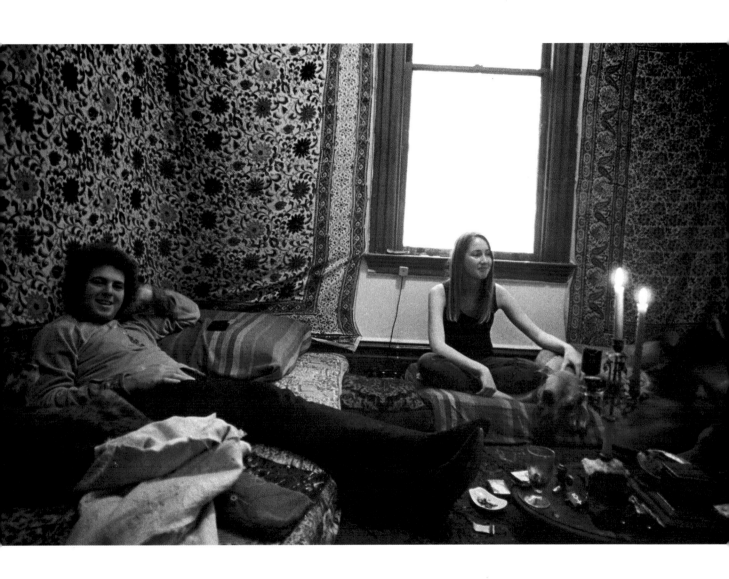

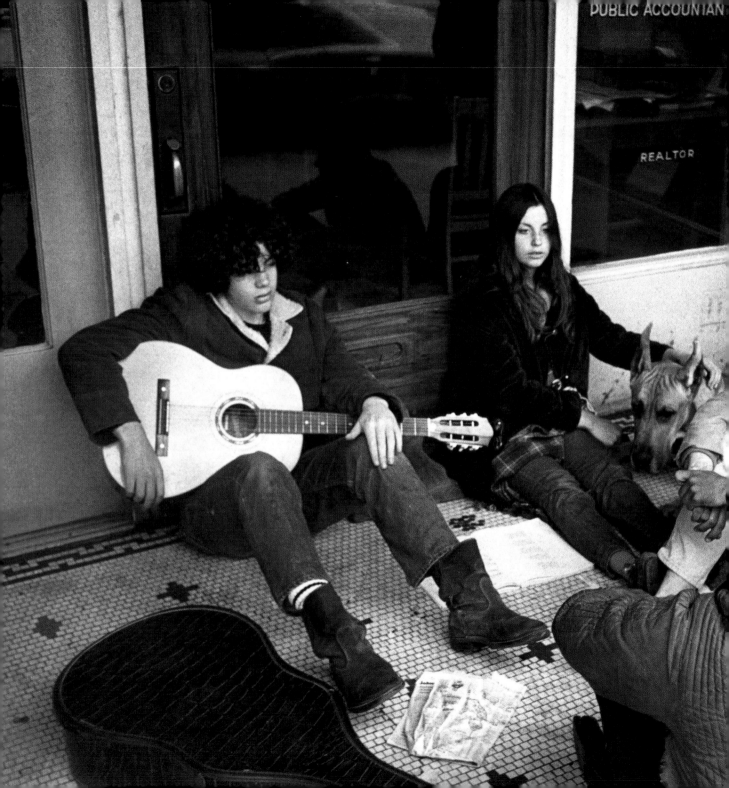

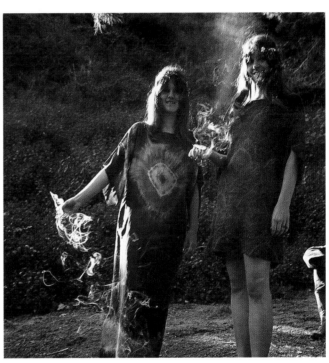

Above: Hippie chicks

Left: Doorway on Haight

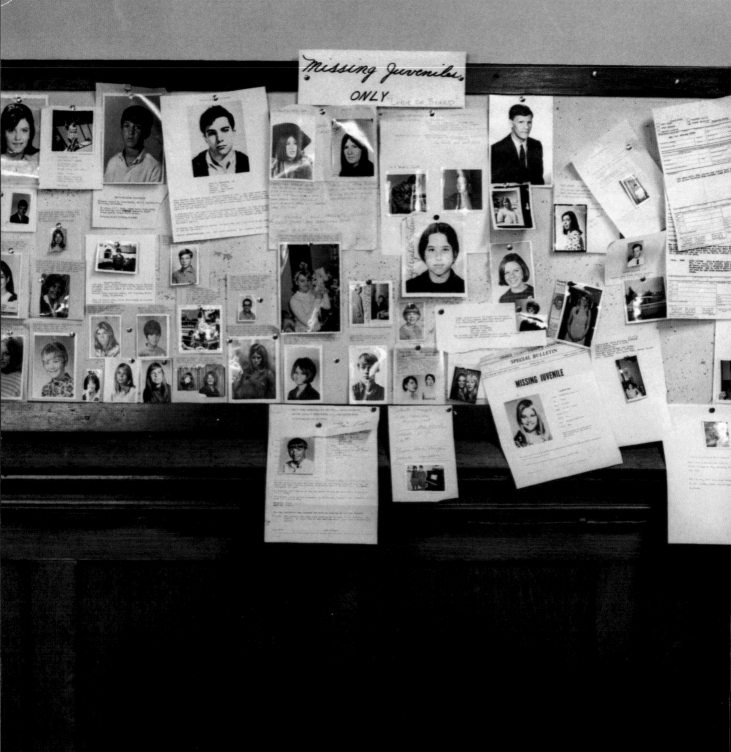

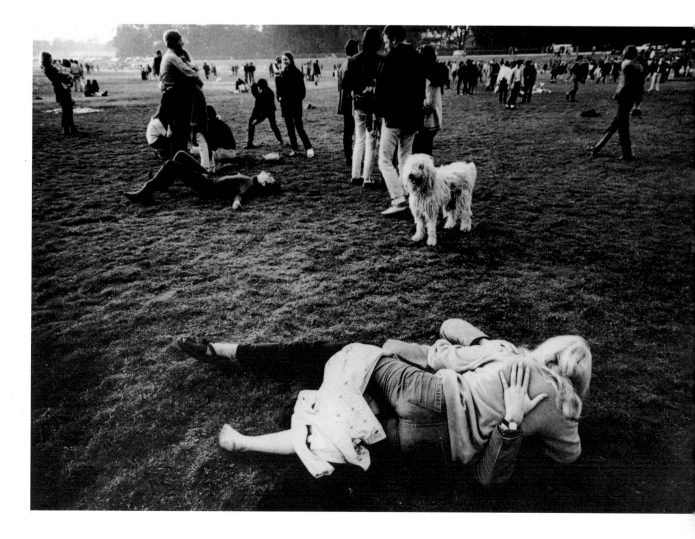

Above: The end of the Be-in

Left: Teenage runaways

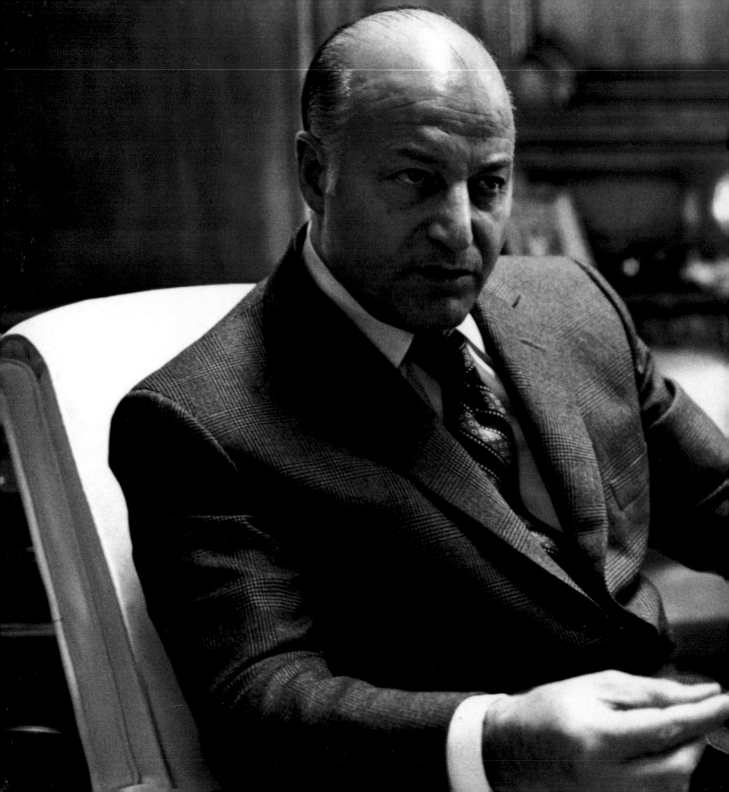

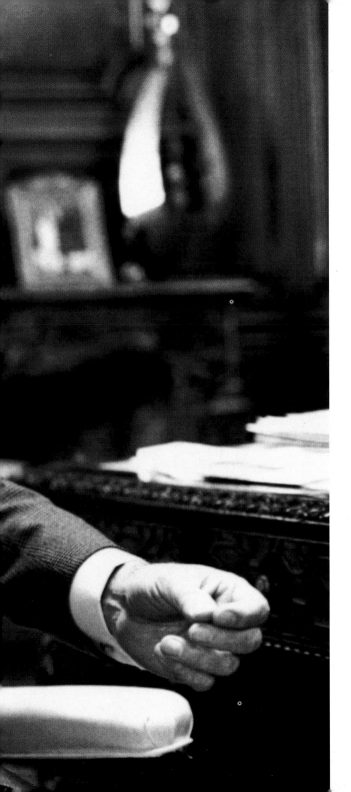

The mayor in his office

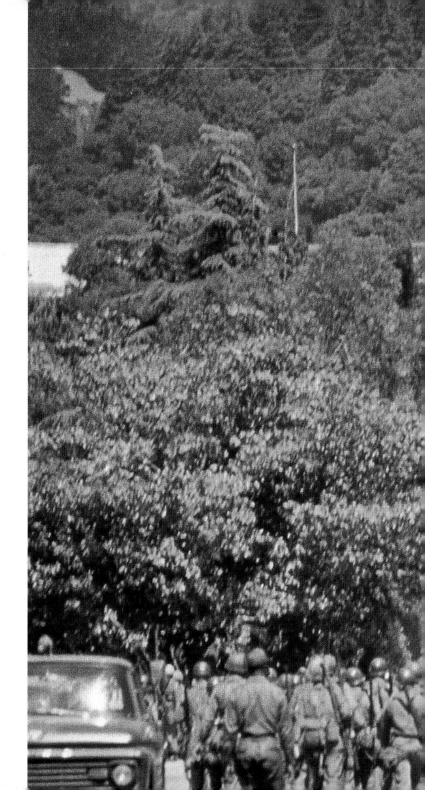

Berkeley in uproar

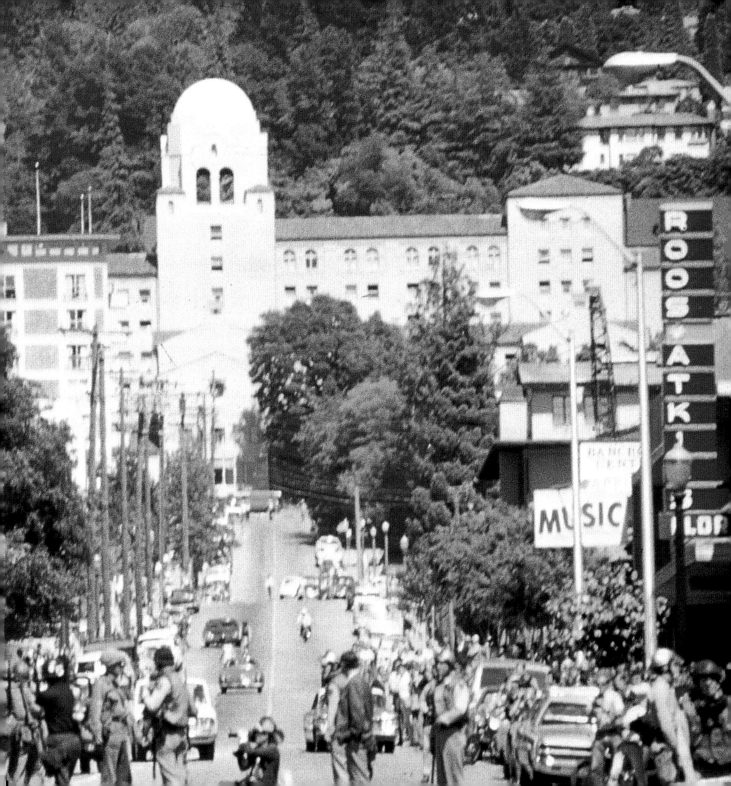

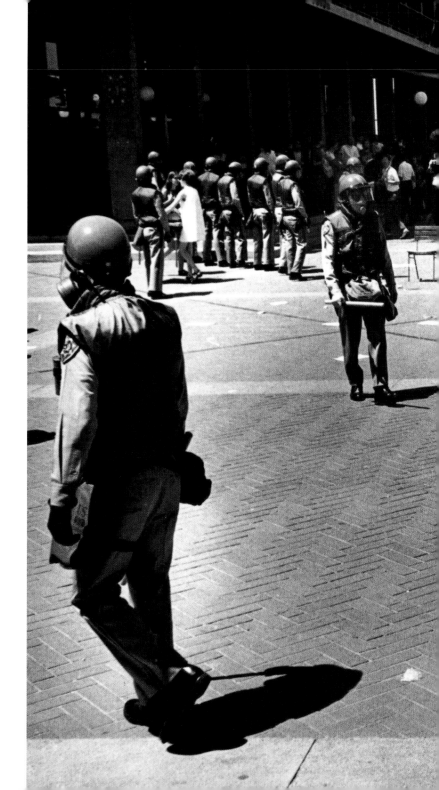

Campus unrest

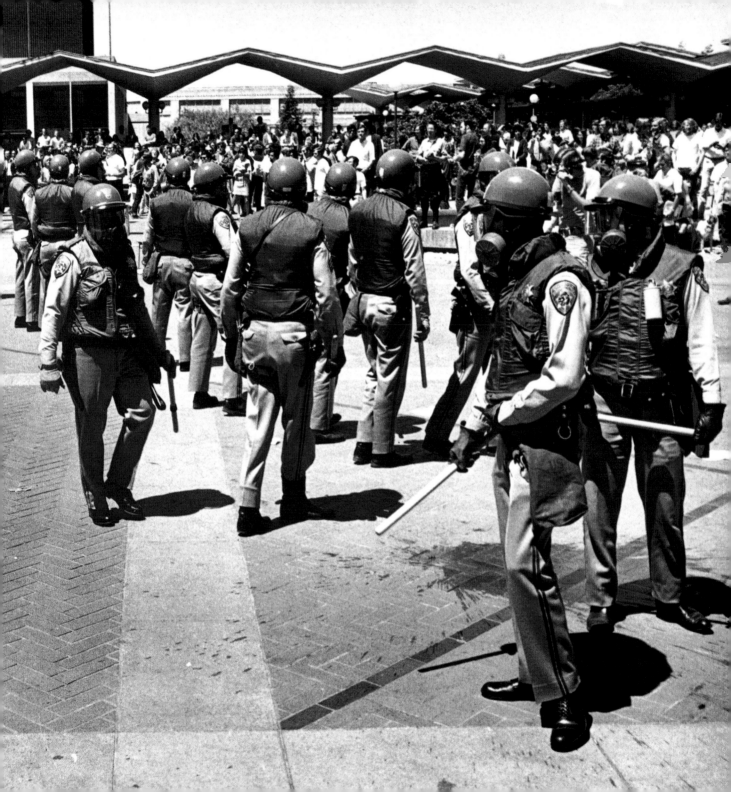

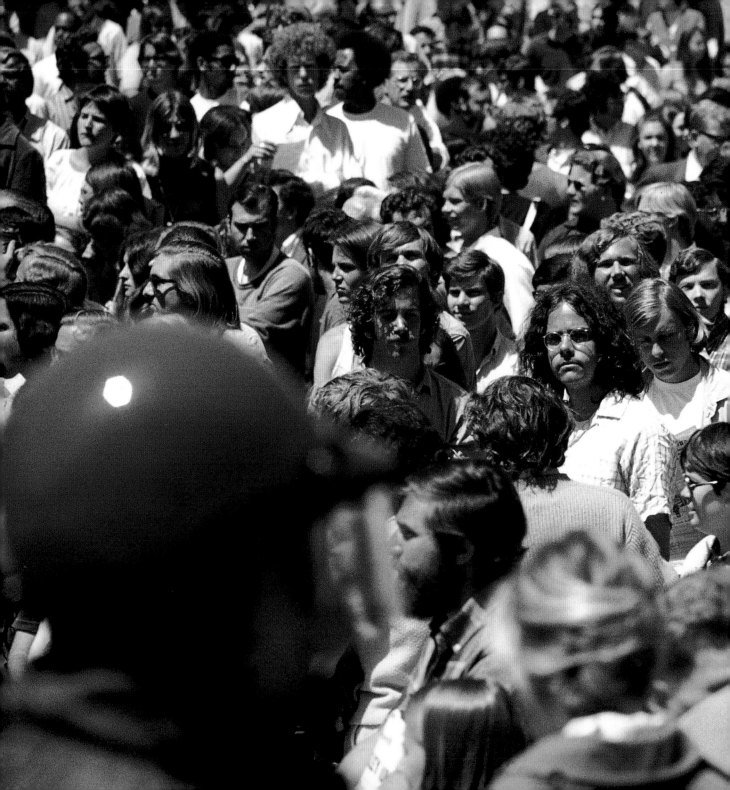

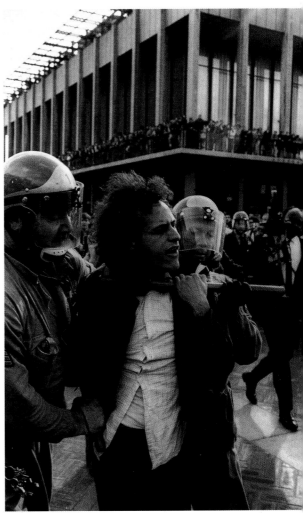

Above: Campus life

Left: Berkeley law and order

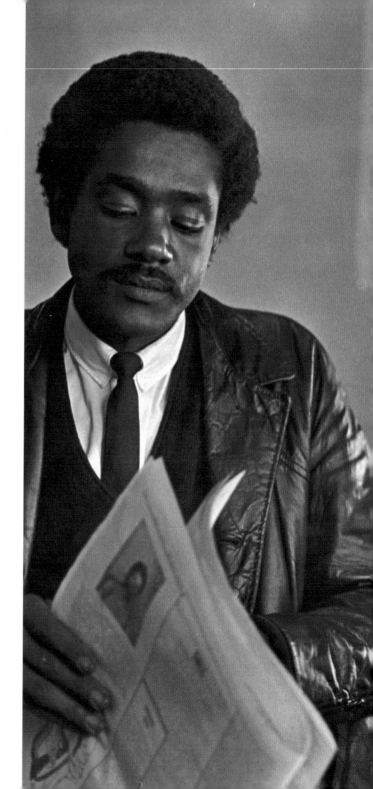

Black militants Huey Newton and Bobby Seale

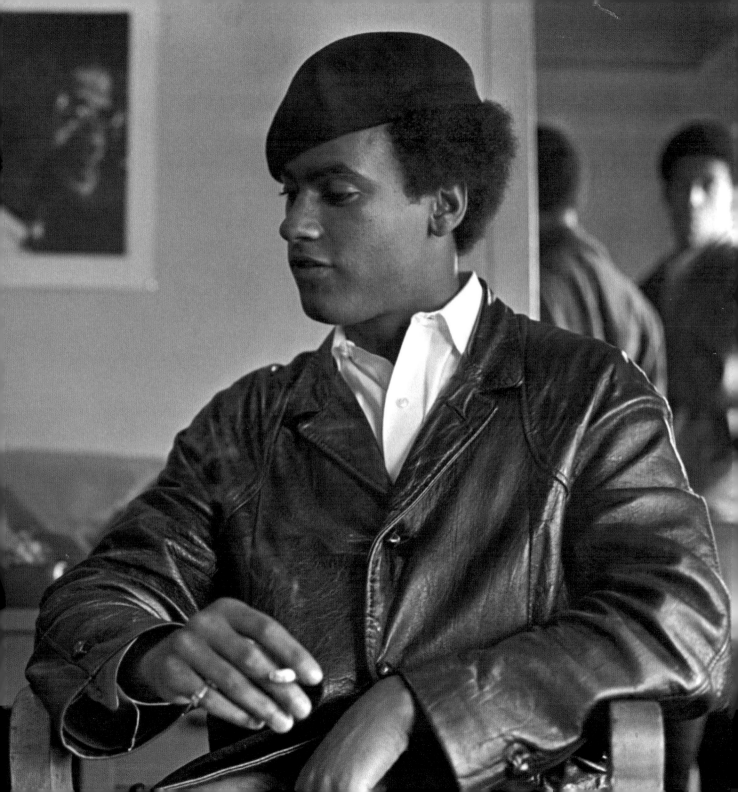

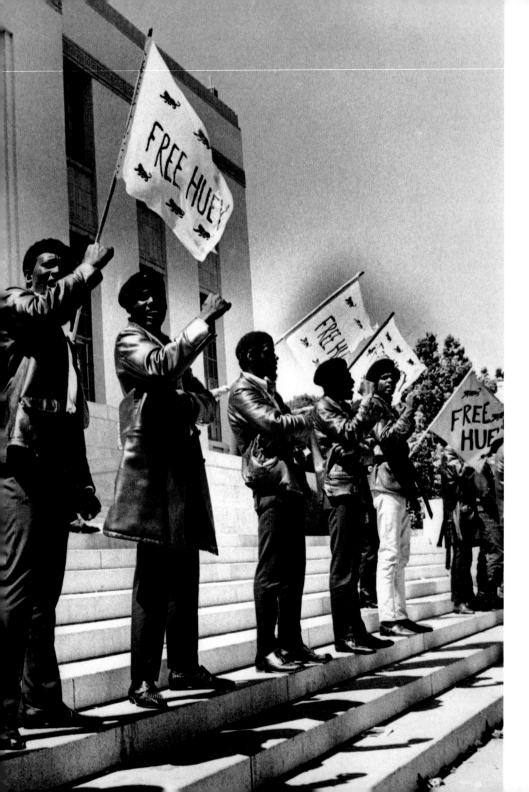

Left: Panthers protest at Huey Newton's trial

Right: Eldridge Cleaver, Black Panther

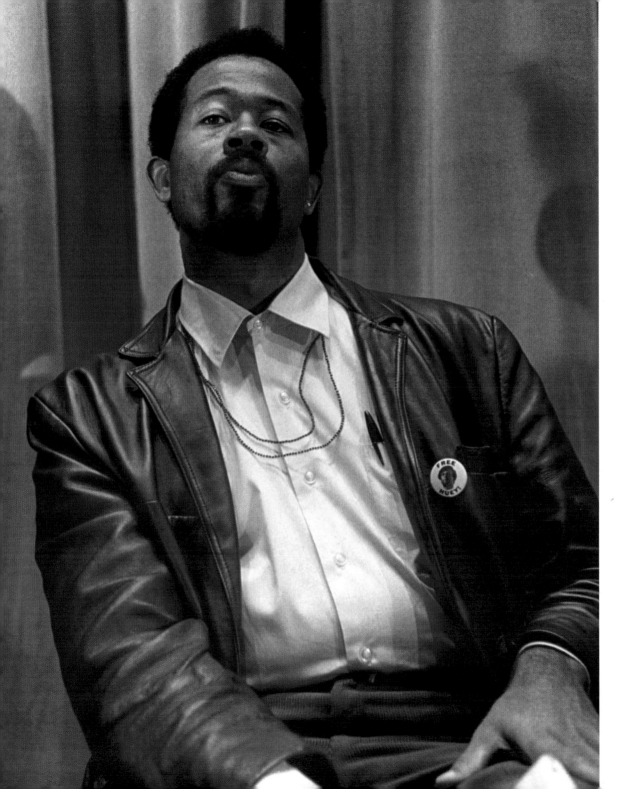

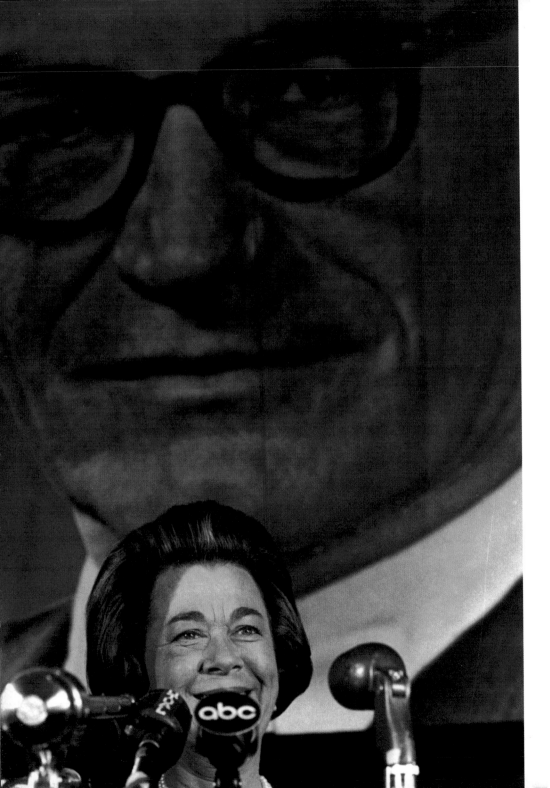

Left: Campaigning for
Barry

Right: The oldest hippie
in town

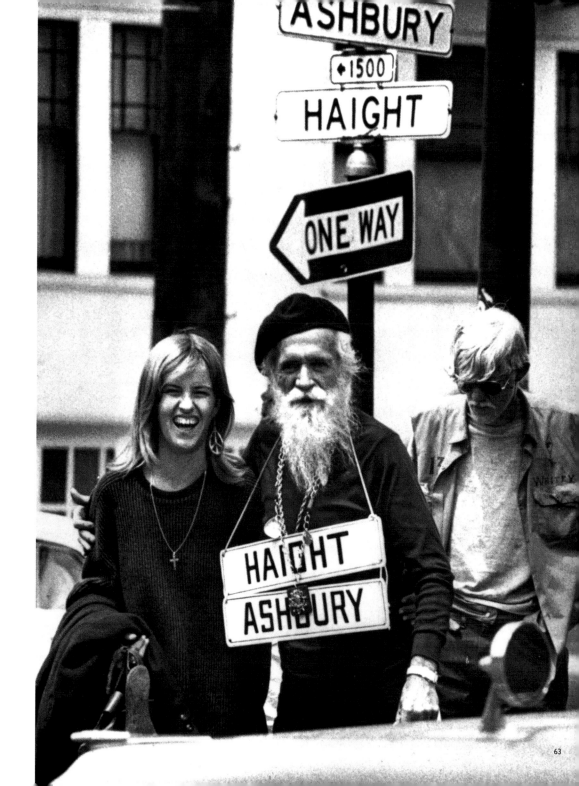

63

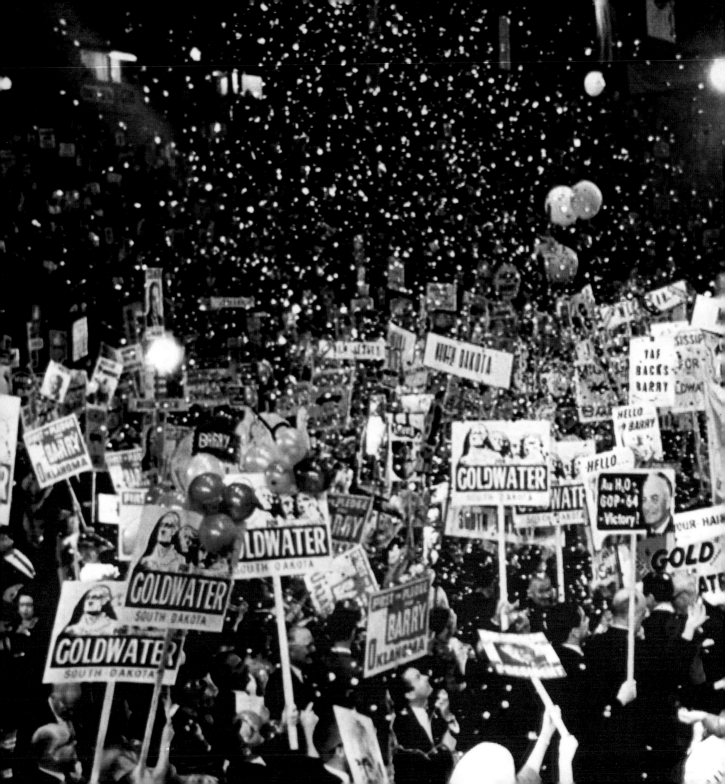

Left: Inside the Cow Palace 1964

Below: Raising the ante for the republicans

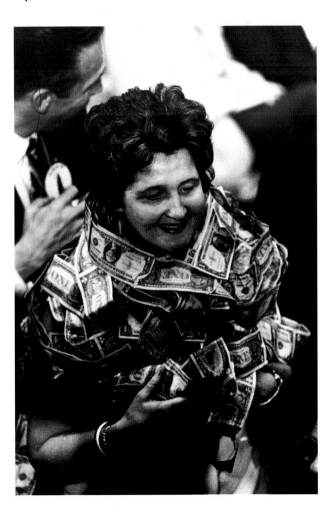

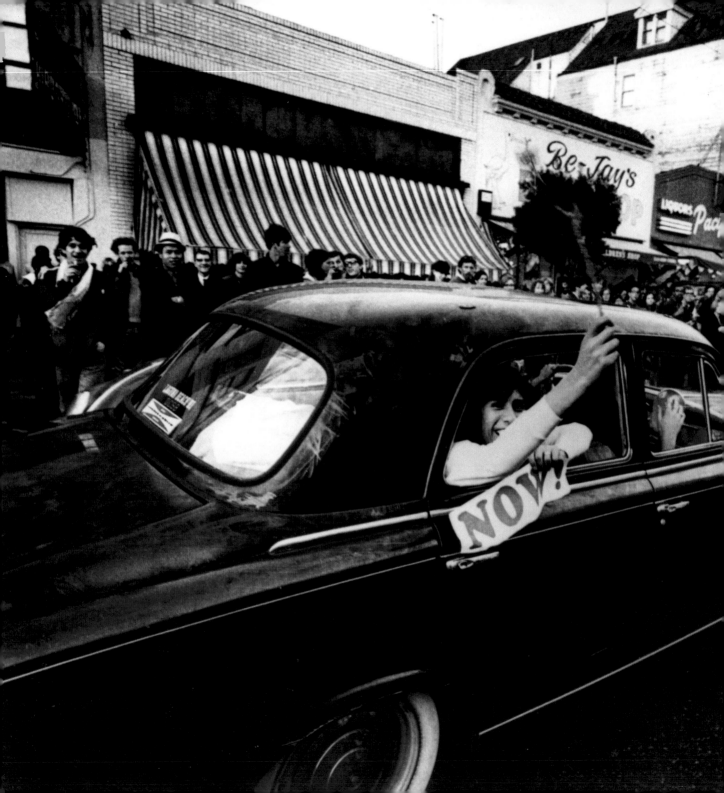

The Death of Money

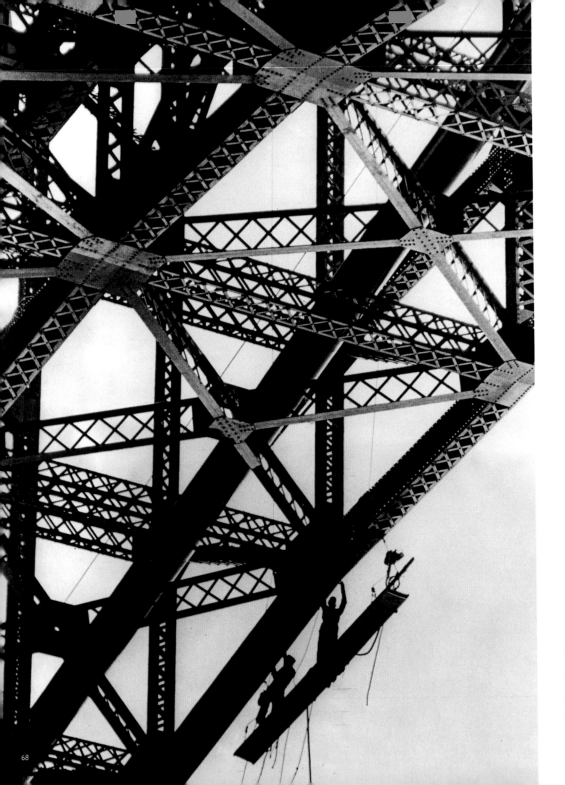

Left: Endless task

Right: The new pyramid

Overleaf: Cable car celebrities

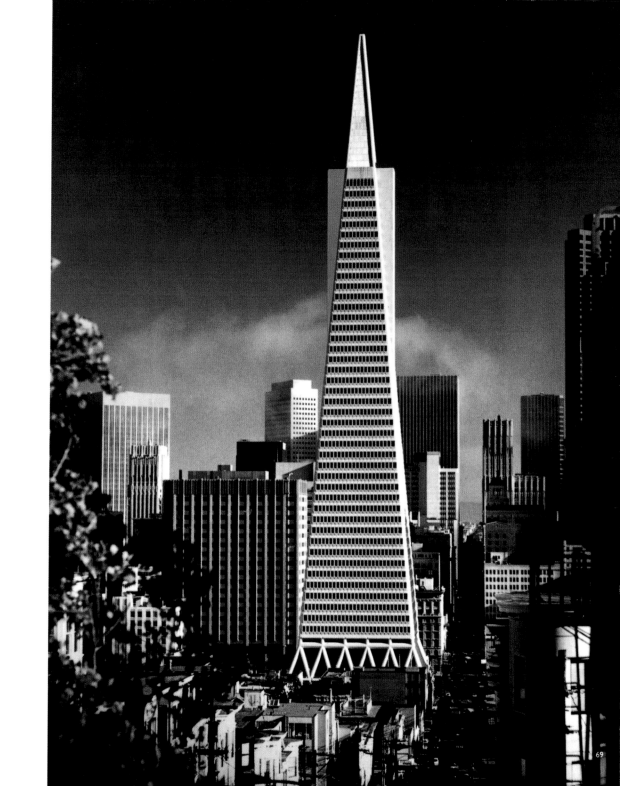

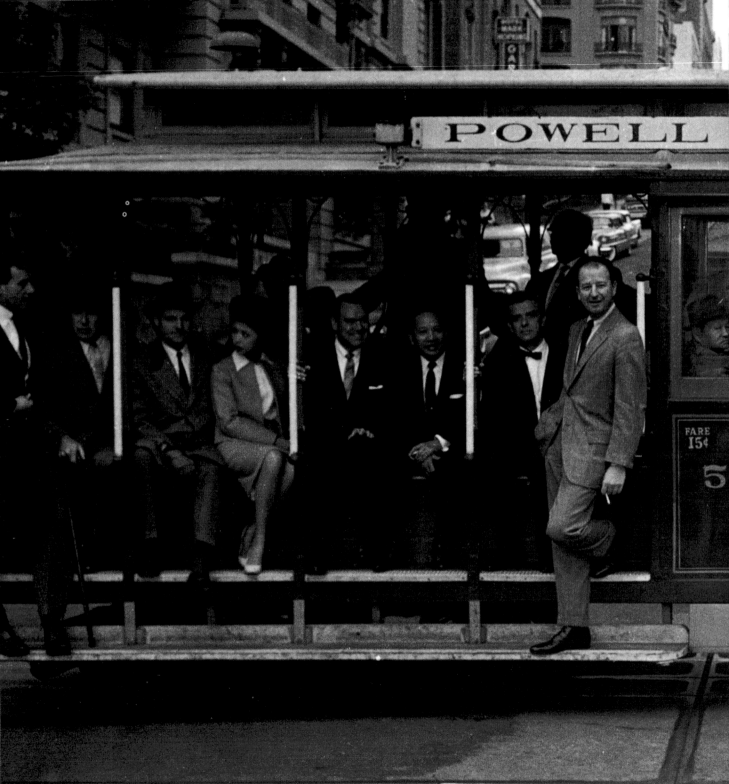

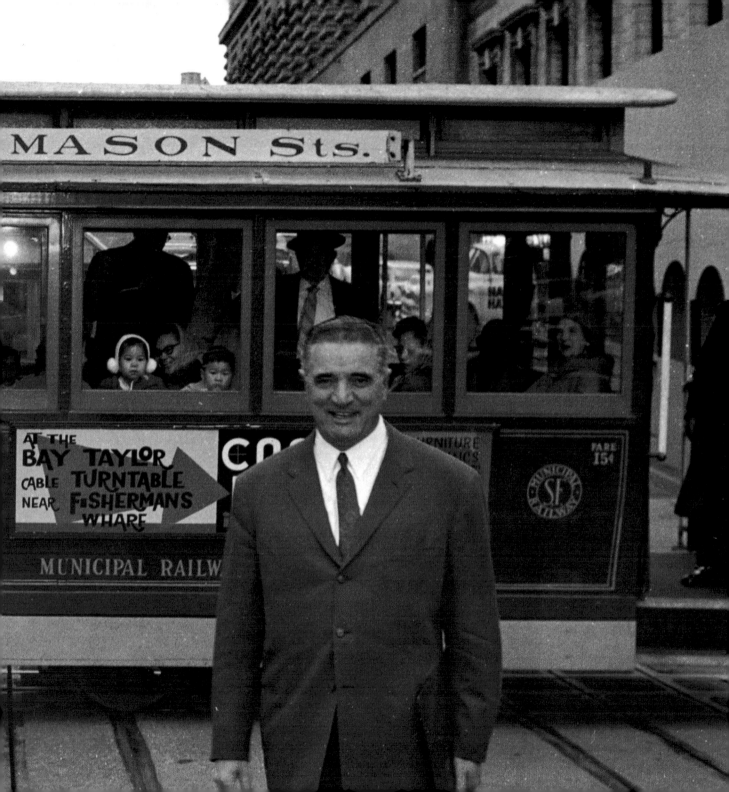

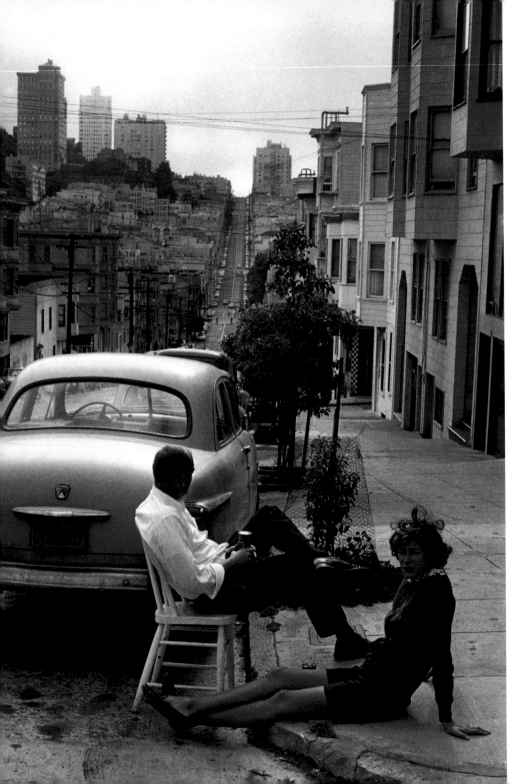

Left: Summer in the city

Right: Face painting in the park

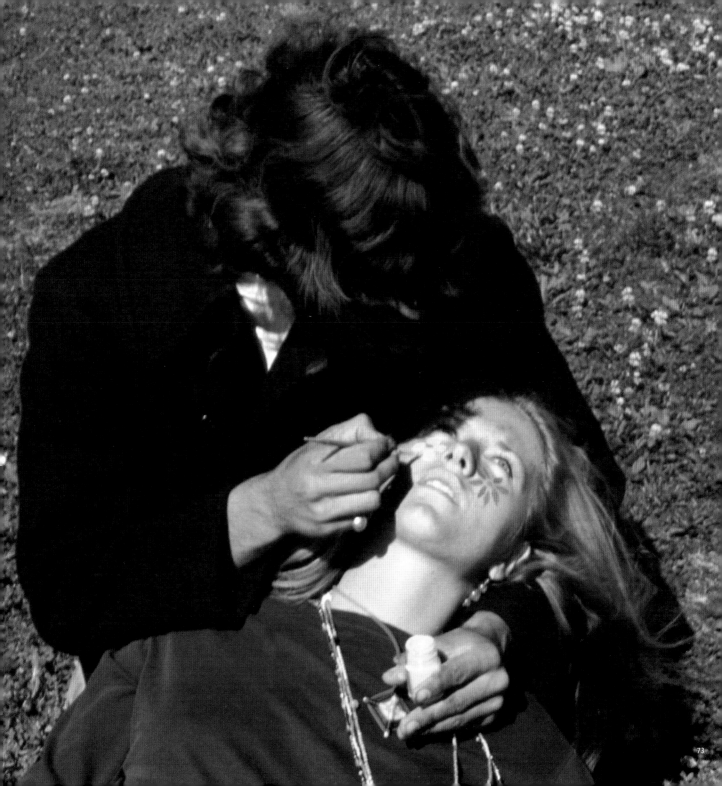

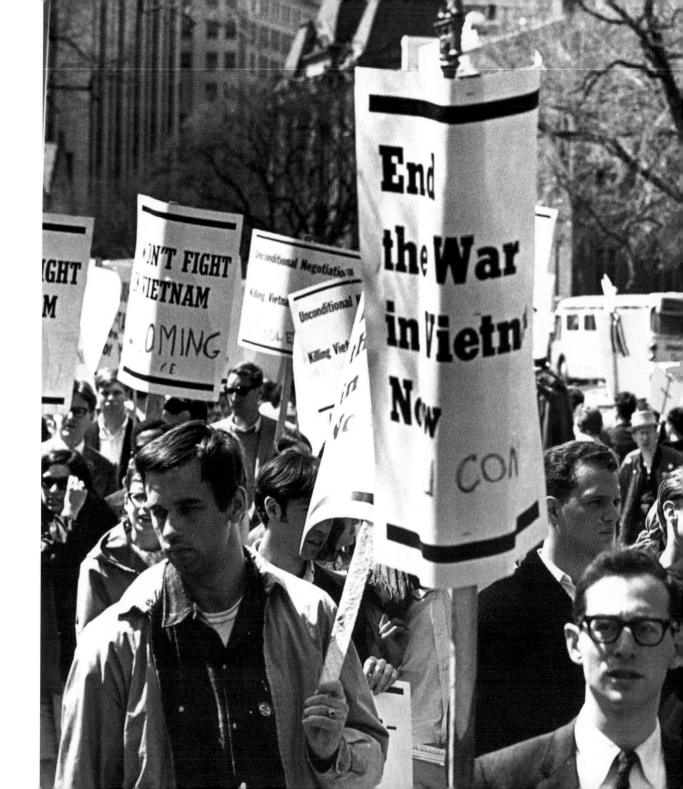

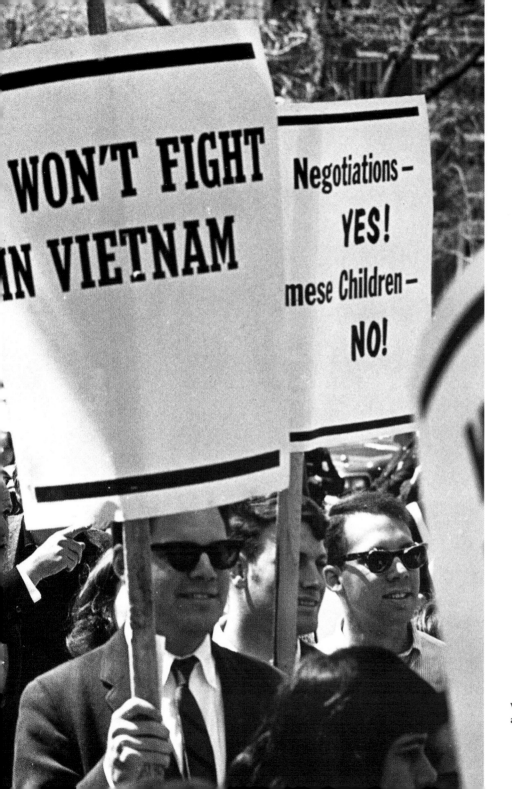

WON'T FIGHT
IN VIETNAM

Negotiations –
YES!
mese Children –
NO!

White-collar,
anti-draft demo

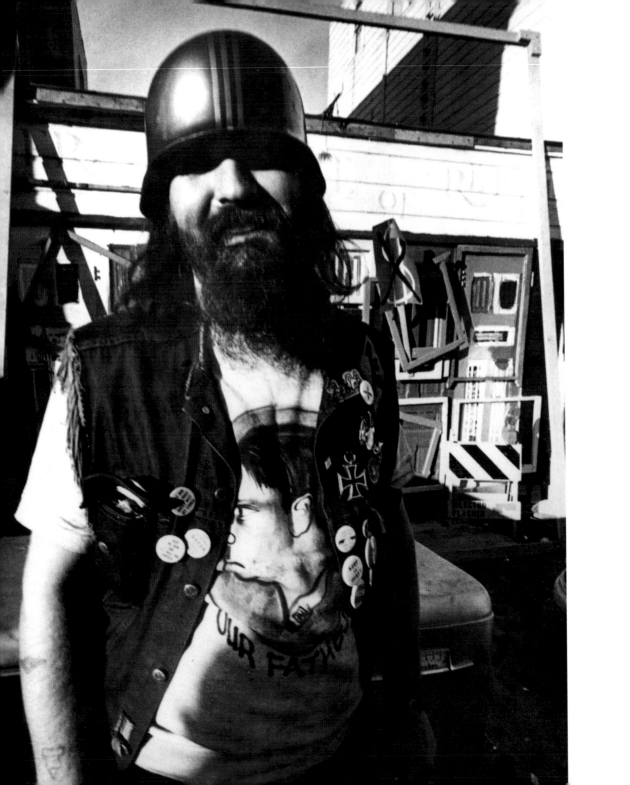

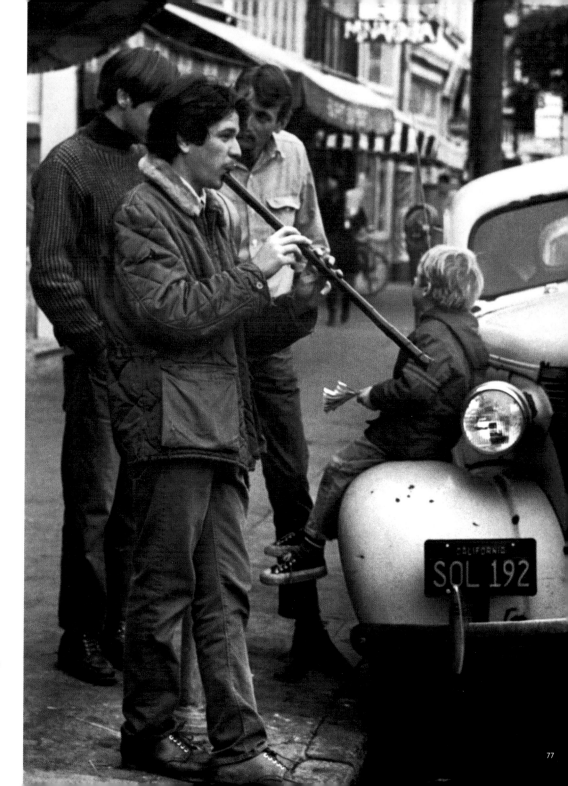

Left: Hell's Angel
Chocolate George
on the defensive

Right: A hippie
toots his flute

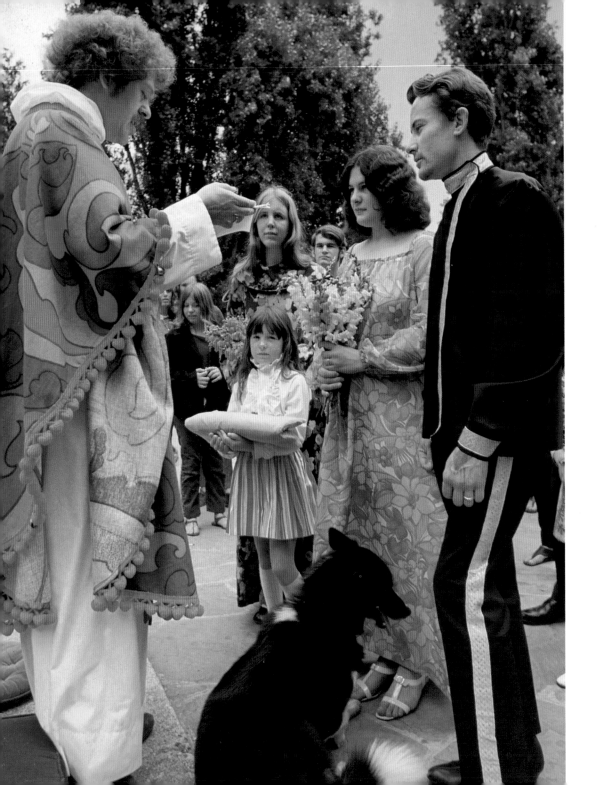

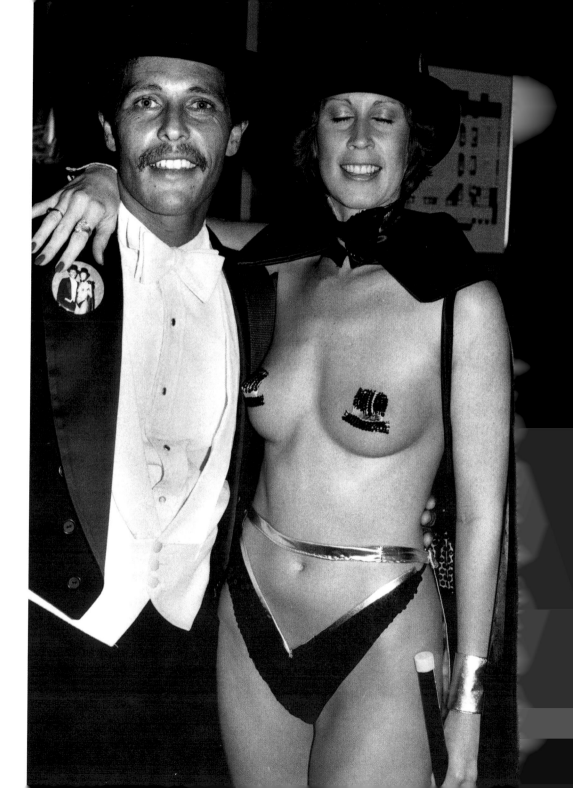

Left: Marriage San
Francisco style

Right: Guests at
the Hooker's Ball

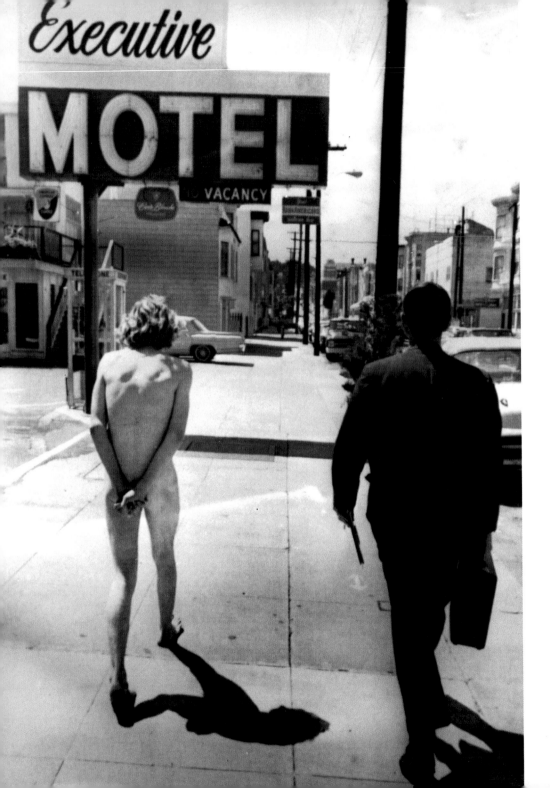

Left: Nature man takes a stroll

Right: Love, Not War

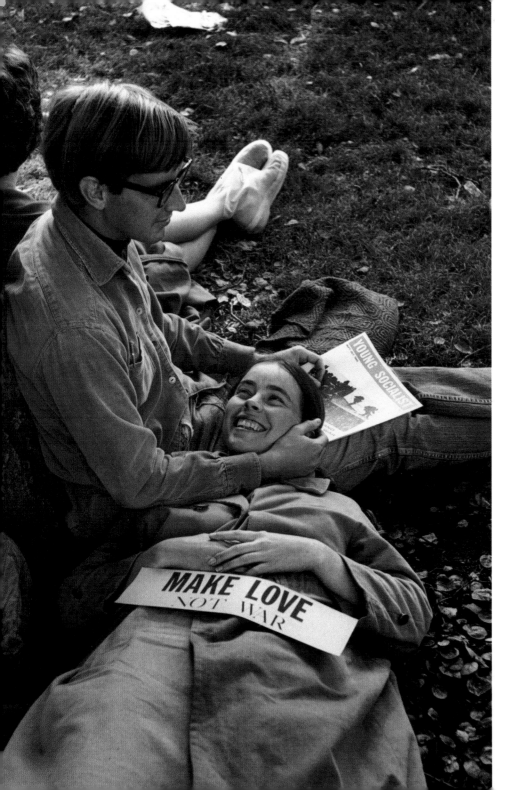

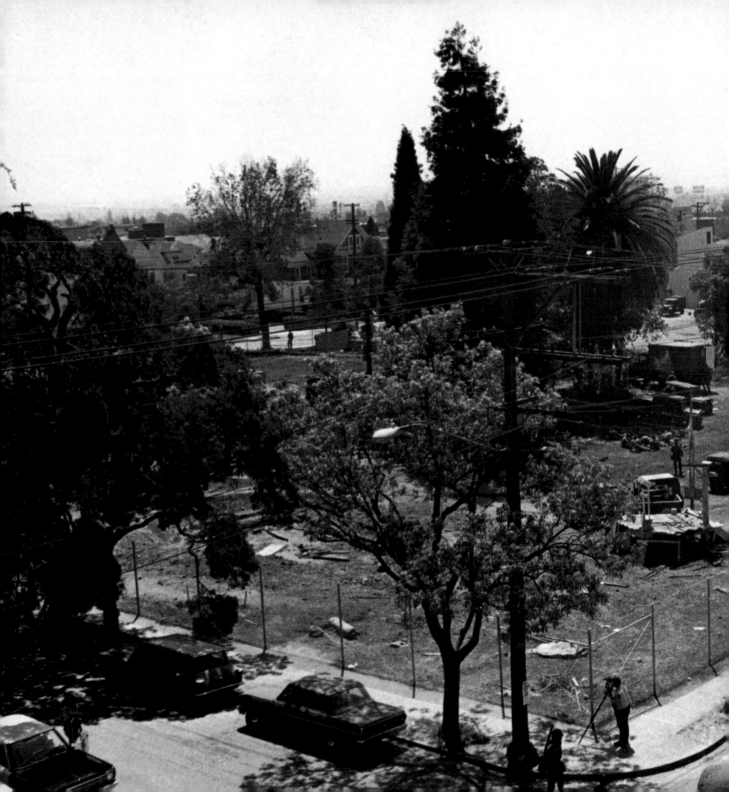

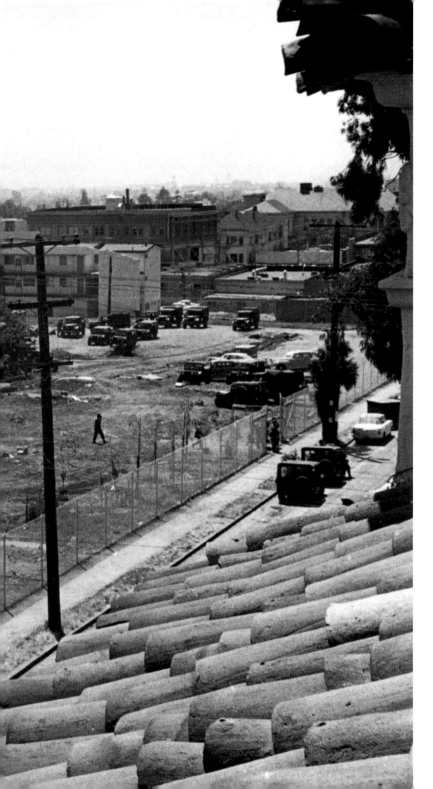

After the battle – the People's Park

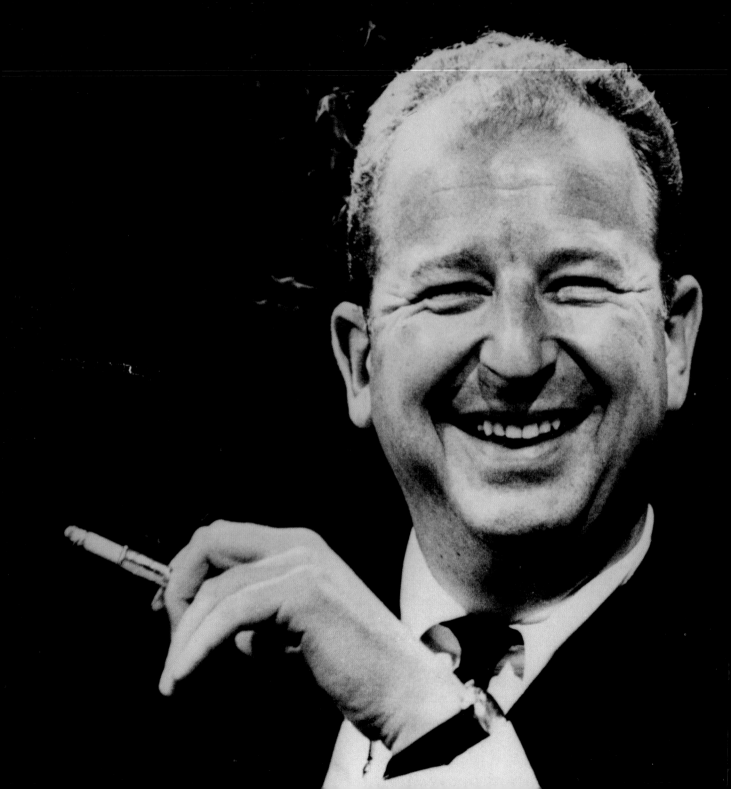

Herb Caen – ace columnist

The face of a Digger

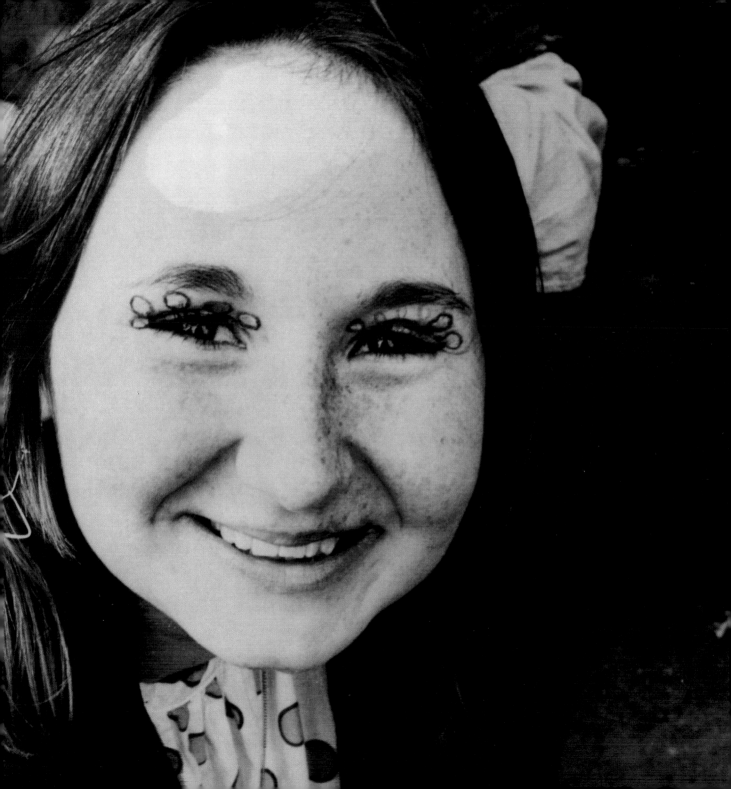

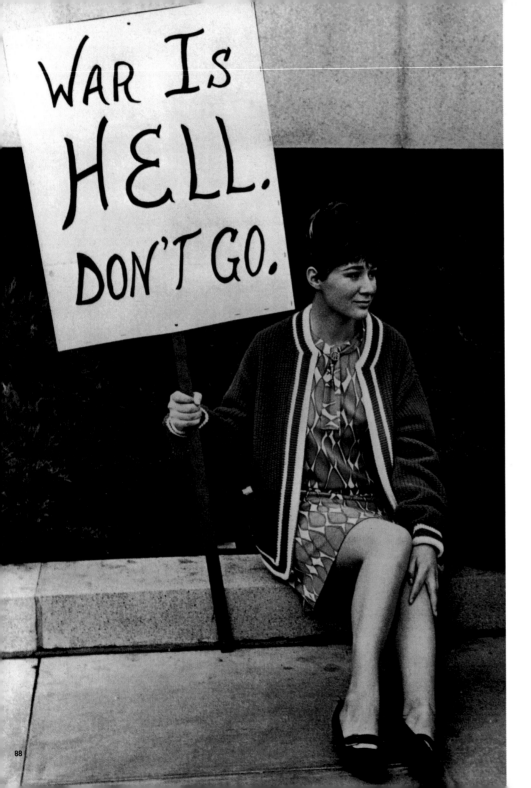

Left: A Vietnam protest

Right: Hippies in a tree

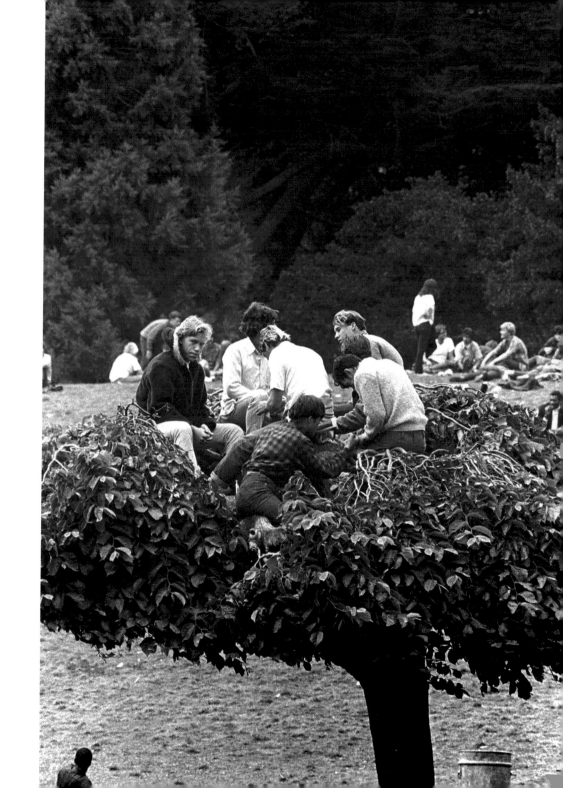

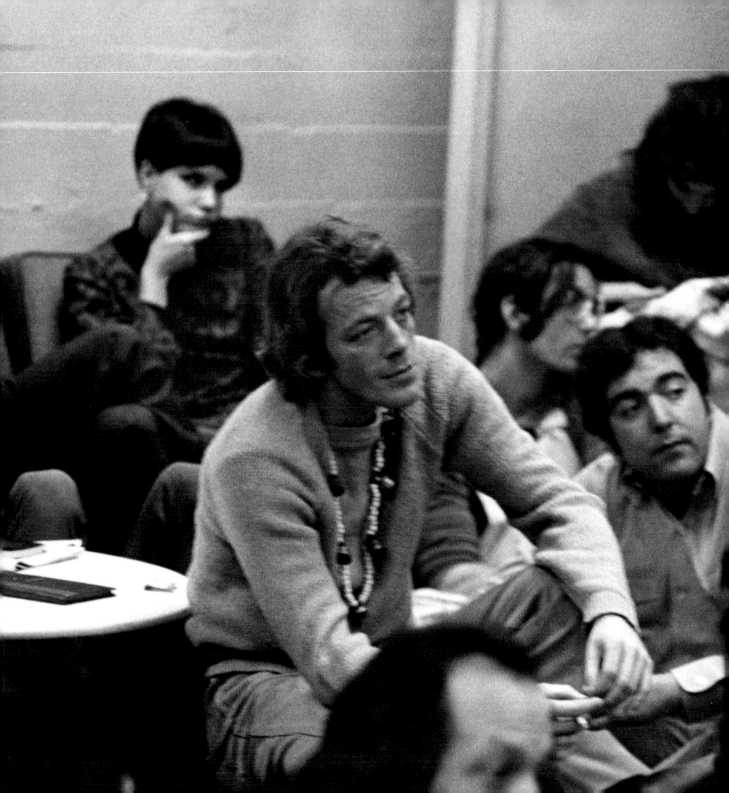

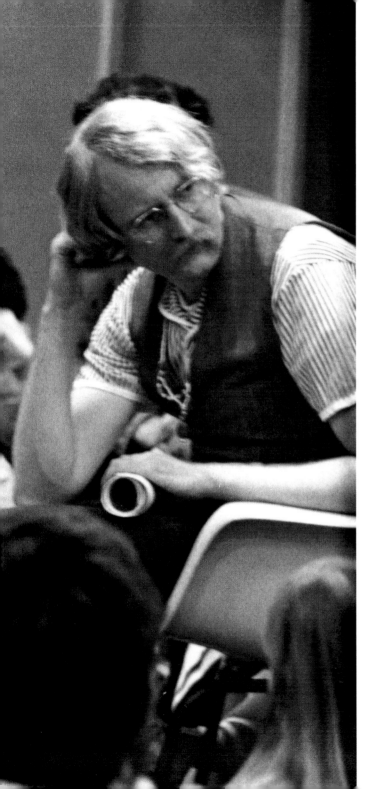

Organized artists meet

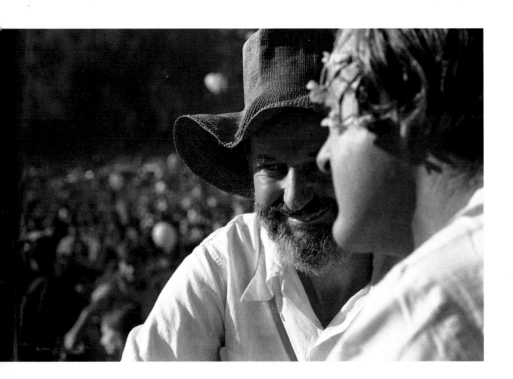

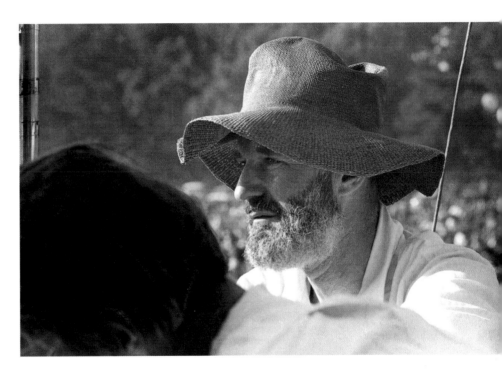

Lawrence Ferlinghetti with Timothy Leary

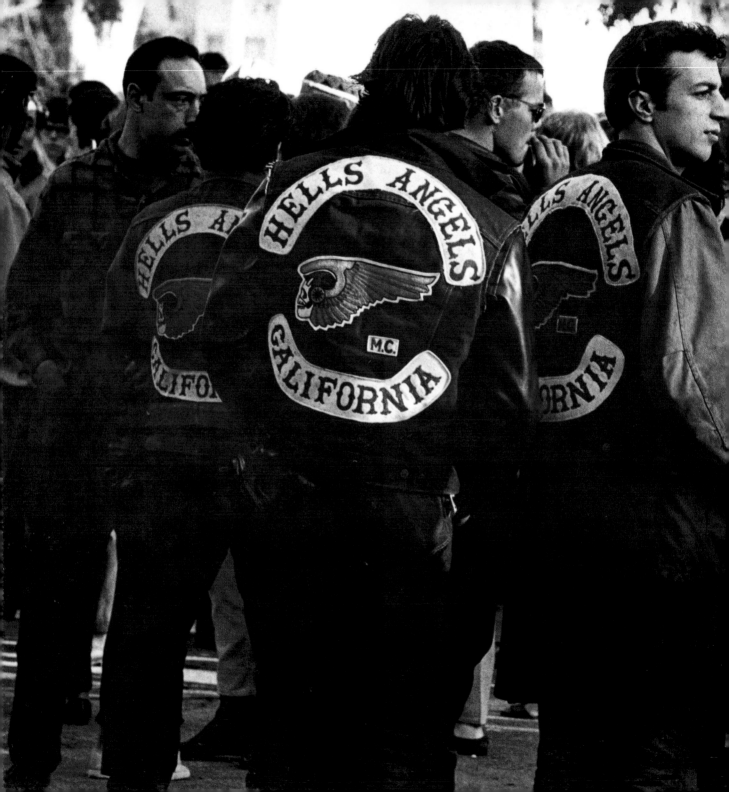

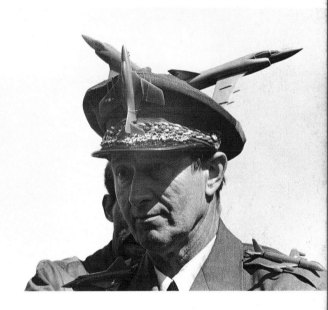

Hell's Angels and General Hershey

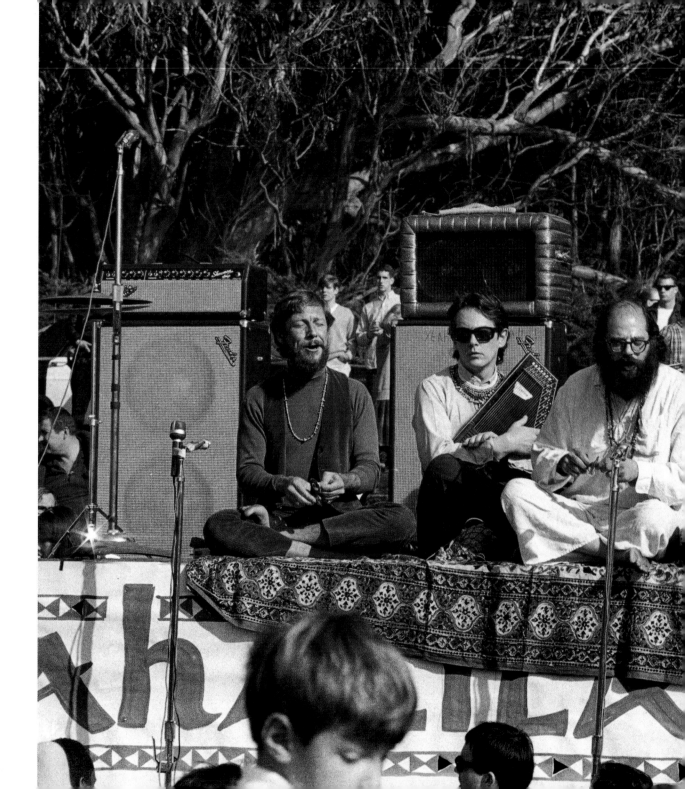

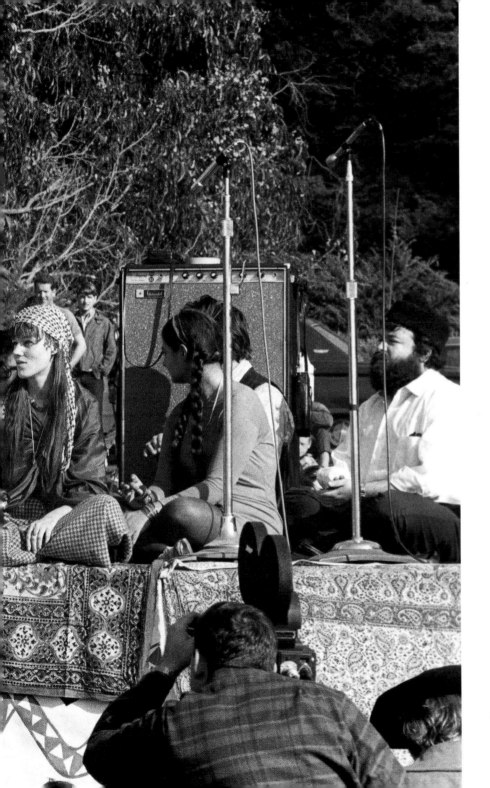

Mantras at the Be-in

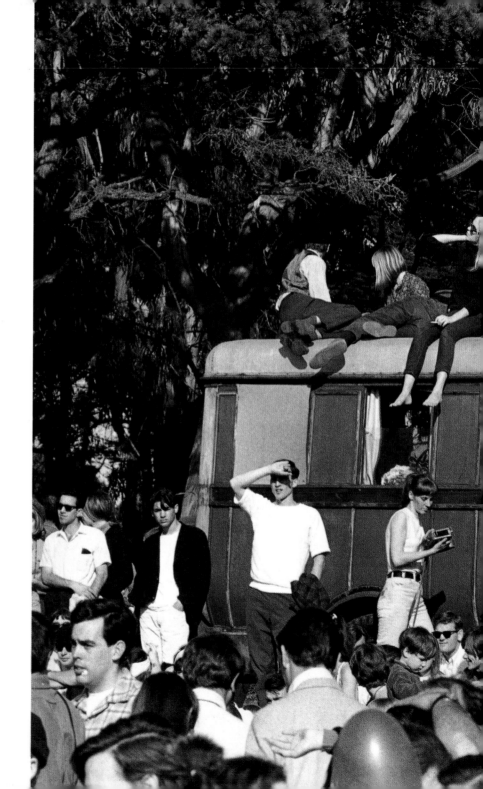

Taking the air, soaking up the sun

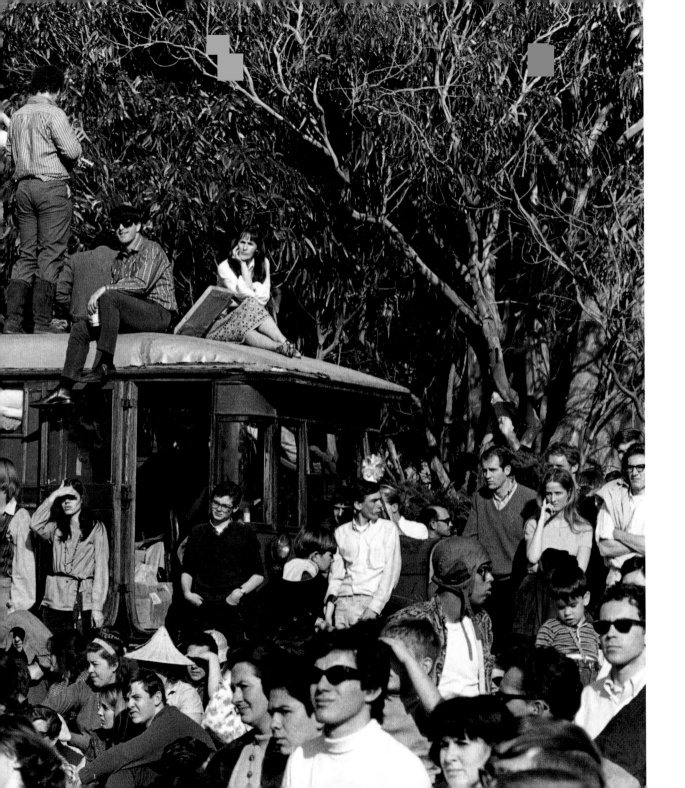

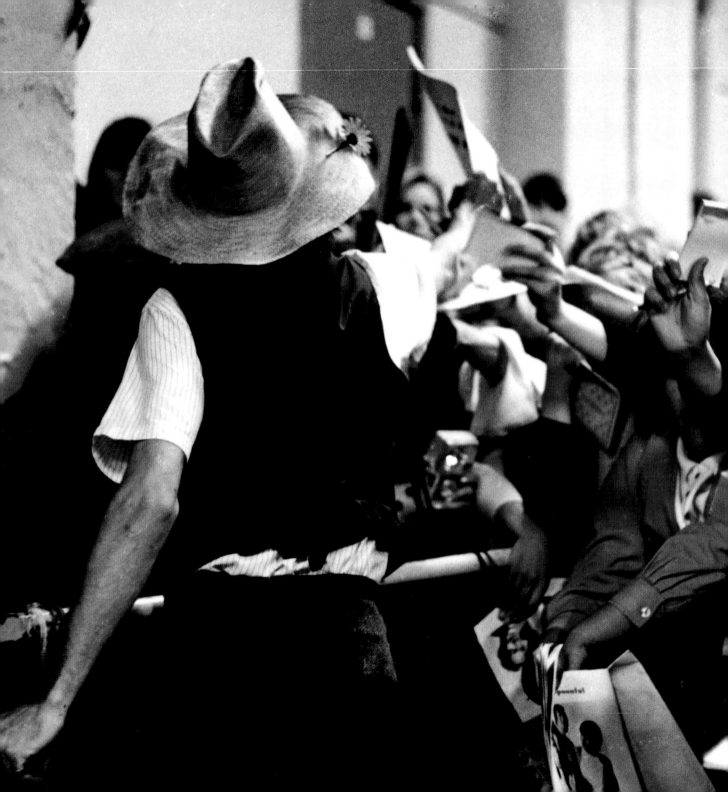

Fans crowd Lovin' Spoonful star

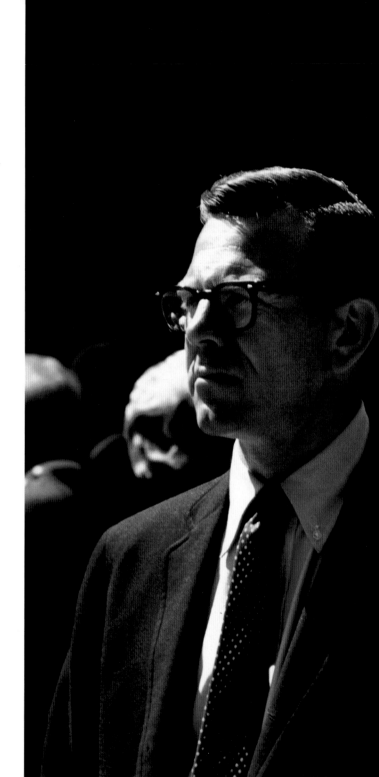

Headlines on the street

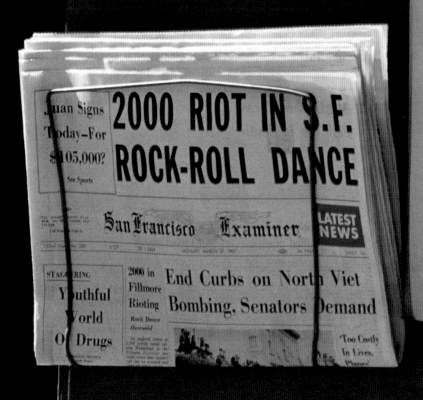

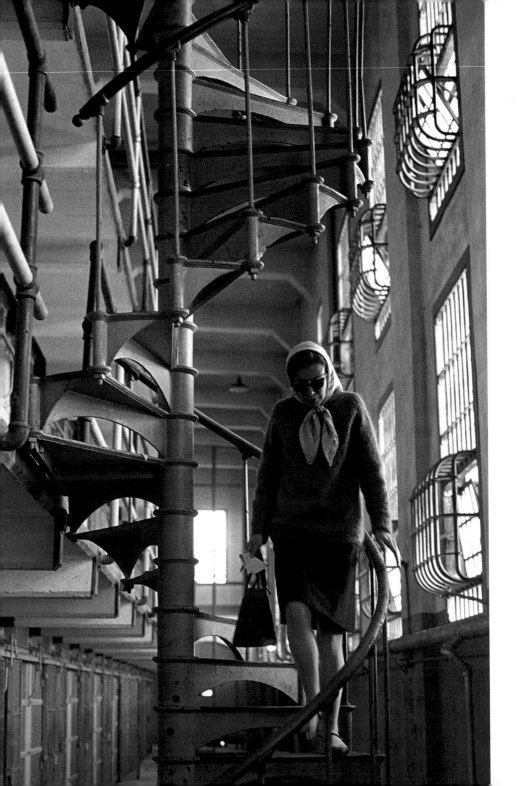

Left: Joan Didion, writer, sight-seeing on the Rock

Right: Writer, John Gregory Dunne (husband of Joan Didion), under the watchtower

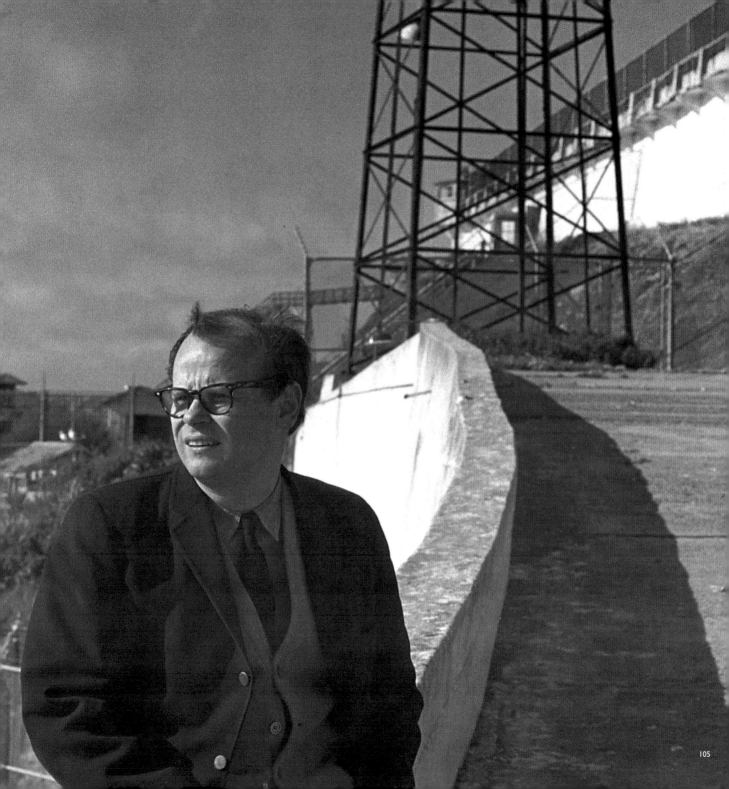

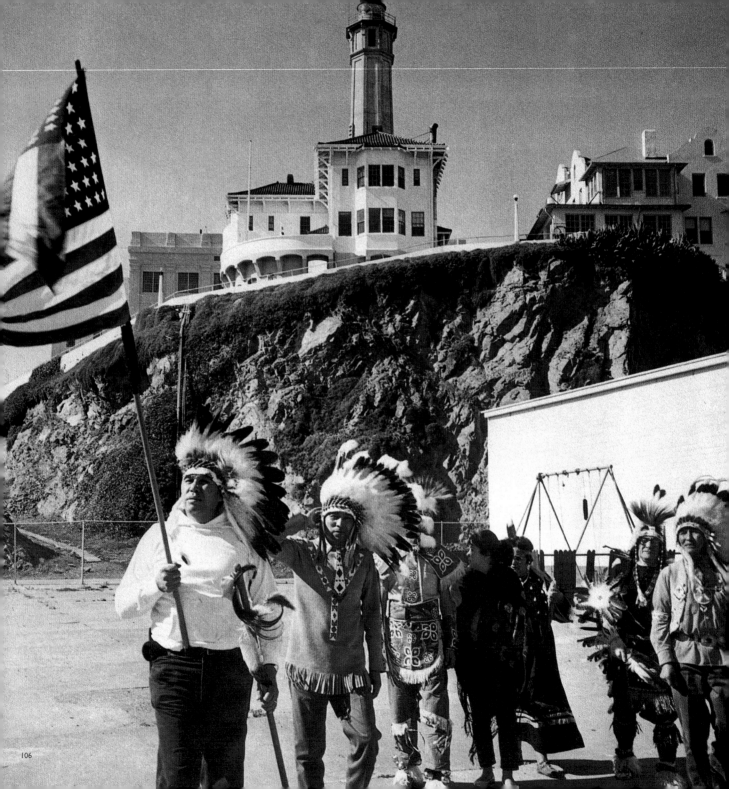

Left: The peaceful Sioux' land grab of Alcatraz

Right: Native Americans feast at Alcatraz Thanksgiving

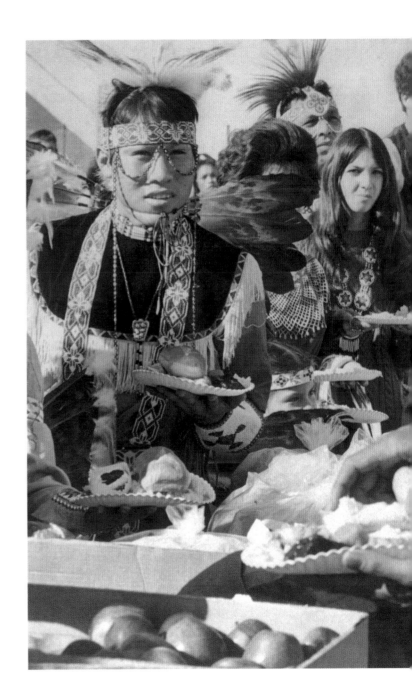

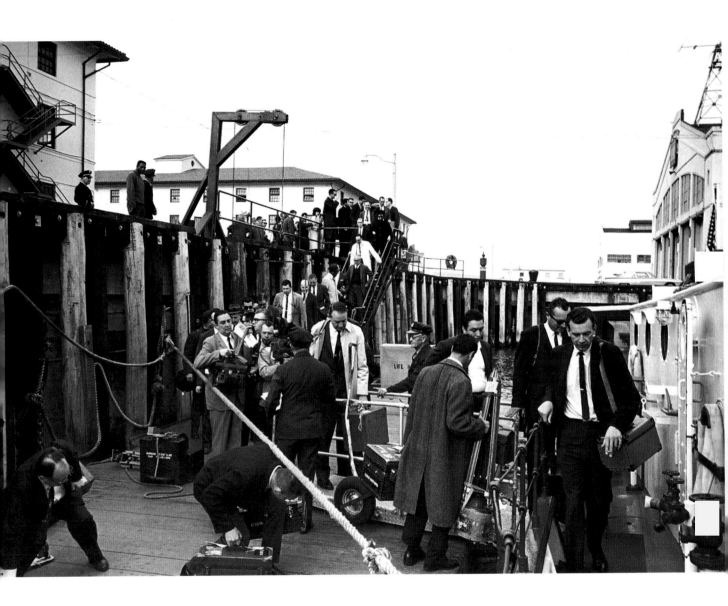

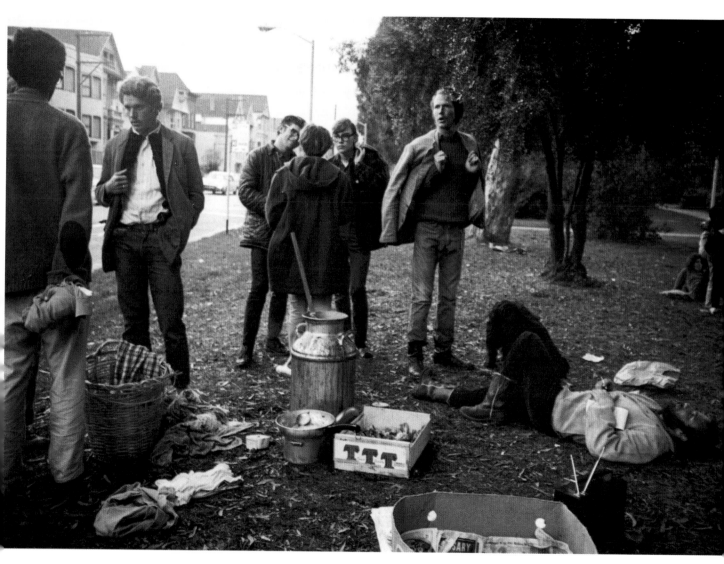

Above: Diggers on the job

Left: Last Day on The Rock – the media men leave

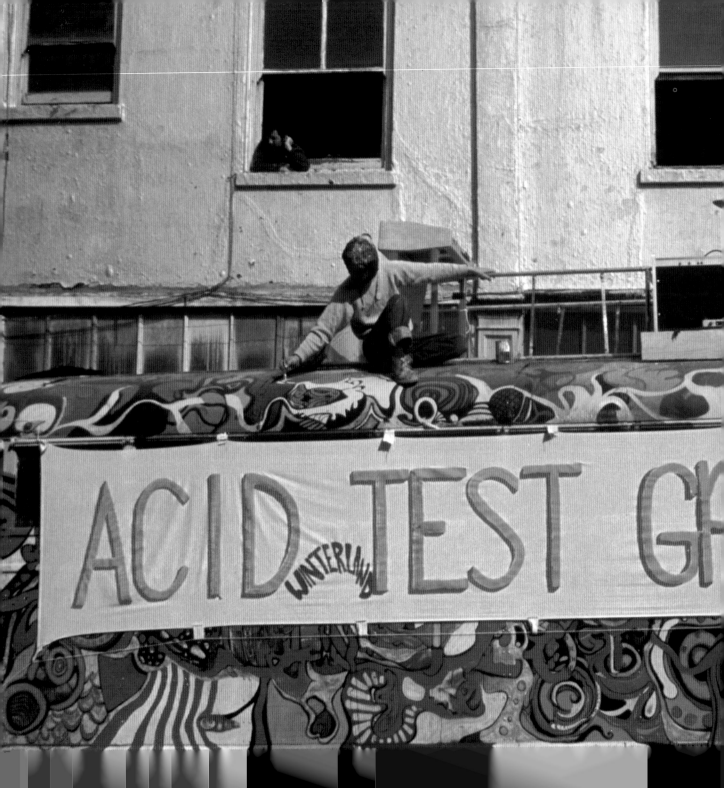

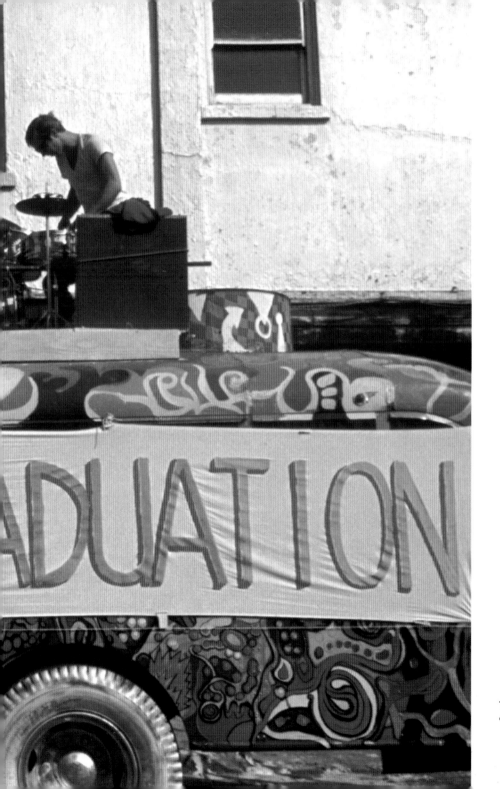

The Merry Pranksters
celebrate

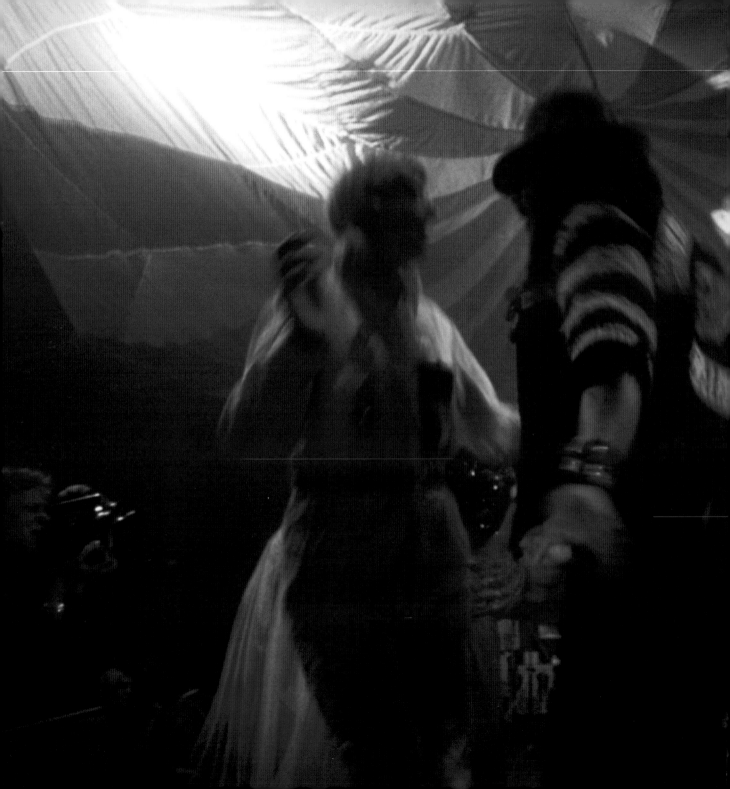

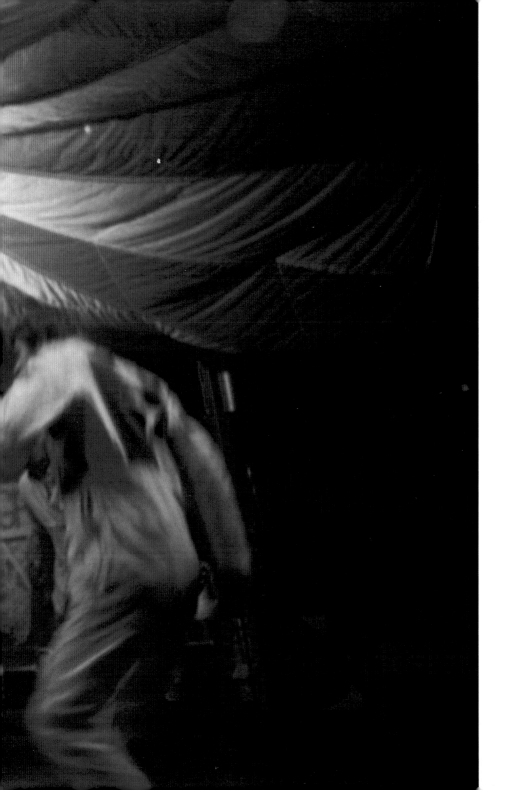

The Acid House jumps

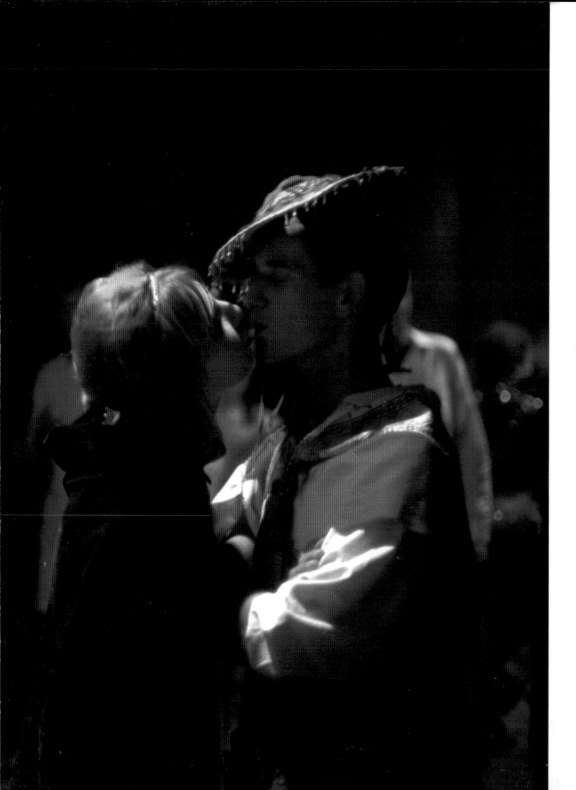

Acid couple kiss

Morning light

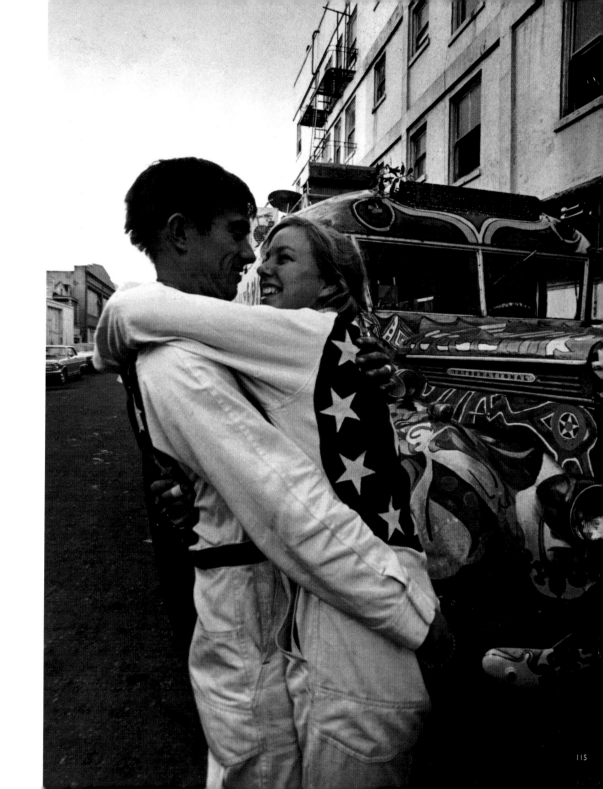

Left: Singer Scott McKenzie – no flower in his hair

Right: Rock radio. A staff photograph of the team behind **KMPX** in 1967

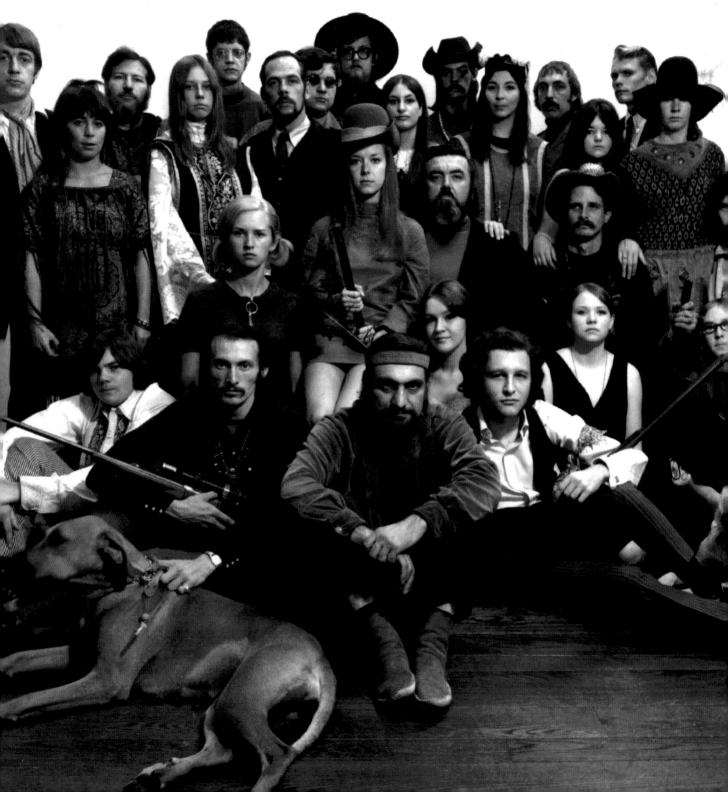

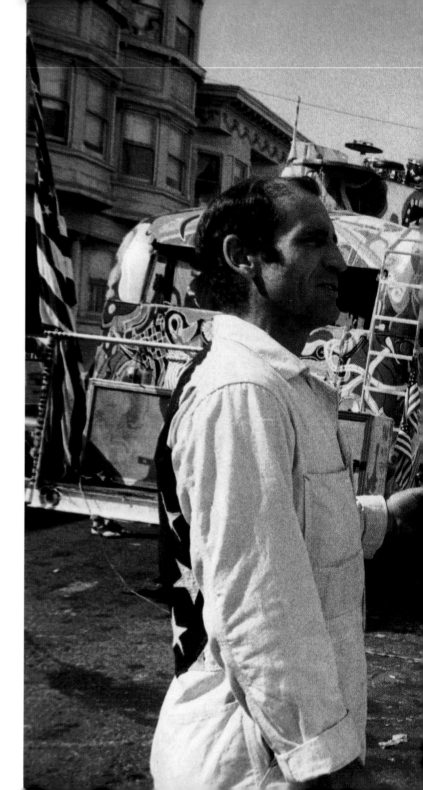

Neal Cassady and Gut

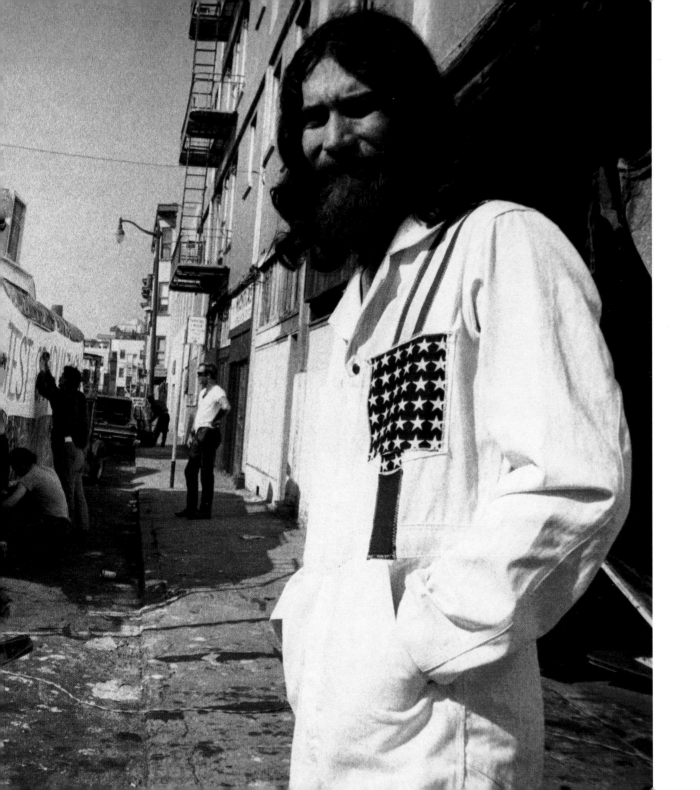

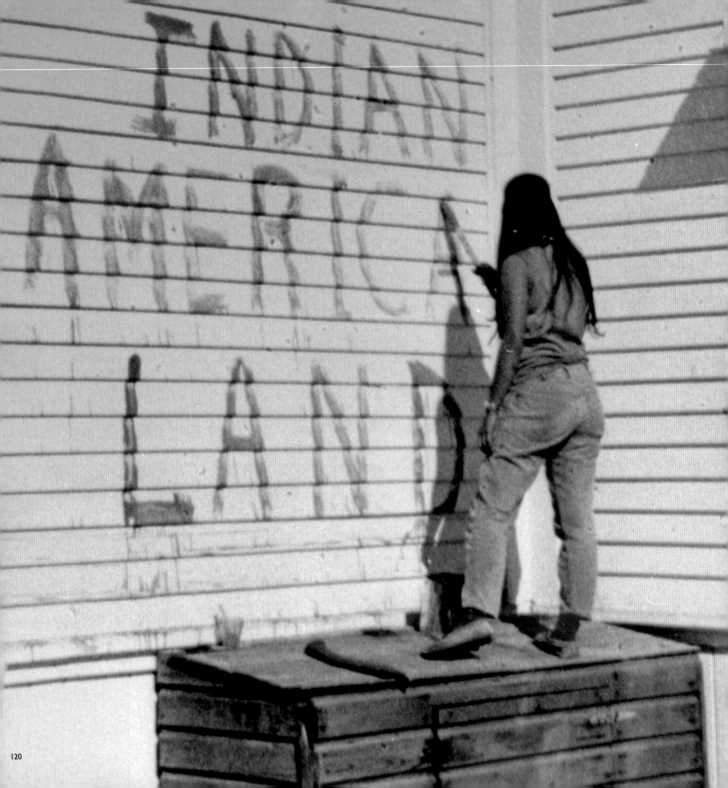

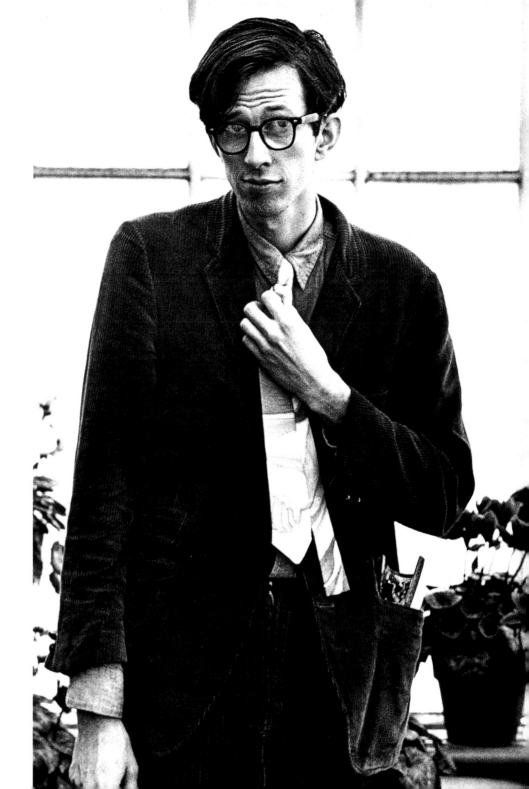

Left: Claiming Alcatraz

Right: Cartoonist and illustrator, Robert Crumb

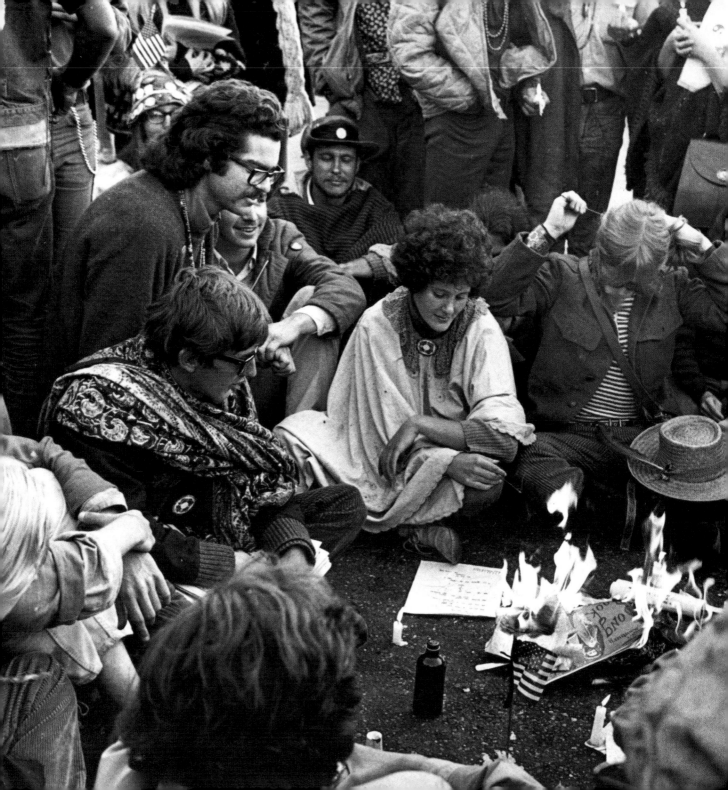

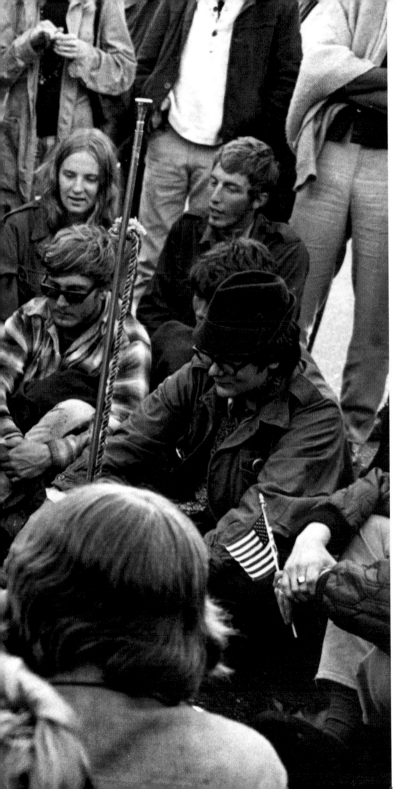

Death of the hippie

PHOTO CAPTIONS

Front cover: 'Painted Ladies' are what San Franciscans call their pretty pre-1906 wood-frame houses. In the 1960s face painting gave the term a more literal sense.
Corbis – Bettmann/UPI

Back cover: (see page 26)
California Historical Society, FN32044, Arthur Roth Collection

Page 5: A gentle protestor wraps himself in Old Glory, and while contravening the US government's code for the correct display of the national flag, makes a forceful point.
California Historical Society, FN32220, Gene Anthony Collection

Pages 10–11: Hippies blow huge soap bubbles at a summer solstice celebration at Golden Gate Park.
© Ted Streshinsky/Corbis

Page 12: Young hippies succumb to the heady fumes and hypnotic beat at the Human Be-in.
© Redferns

Pages 12/13: Young people in Haight-Ashbury rest in a doorway in their quest for truth and love.
Corbis/Bettmann/UPI

Page 14: Old wooden houses, some having survived the 1906 fire, were still standing in North Beach in the late 1960s.
Dennis Stock/Magnum

Page 15: A cable car hauls itself up the first hill on its way to the Powell and Market turnaround, with Alcatraz island and its now vacated prison in the background.
© Bettmann/Corbis

Page 16: Notices displayed on a Haight-Ashbury door are overshadowed by the neighbourhood motto, a precept for its chosen way of life.
Michael Ochs Archive/Redferns

Page 17: A psychedelic album sleeve proclaims the trendsetting 1960s group, The Byrds.
Rex Features

Pages 18–19: An early cry for green peace is publicized on a decorated car.
Rex Features

Page 20: Bill Graham, proprietor of the Fillmore auditorium, is elated at receiving his dance hall permit, allowing one of the 1960s most famous venues to operate.
California Historical Society, FN32040, Gene Anthony Collection

Page 21: Bill Graham prepares the sound system for a gig at the Fillmore Auditorium.
Michael Ochs Archive/Redferns

Pages 22–3: Bill Graham made spectacular use of light-shows during gigs at the Fillmore Auditorium.
© Ted Streshinsky/Corbis

Page 24: One of San Francisco's most popular bands of the era, the Grateful Dead, poses for publicity on the front of a steam locomotive.
Herb Greene/Redferns

Page 25: Jerry Garcia, leader of the Grateful Dead wears an Uncle Sam hat and snaps a salute.
California Historical Society, FN3205, Gene Anthony Collection

Page 26: The seedy intersection of Haight and Ashbury Streets in the 1960s became the epicentre of the hippie movement.
California Historical Society, FN32044, Arthur Roth Collection

Page 27: Young (some very young) people gather for an outdoor gig by the Jefferson Airplane. While waiting for the action an impromptu turn on the bongo drum is provided by an audience member.
Michael Ochs Archive/Redferns

Page 28: Neal Cassady shakes a canister thought to contain an LSD-based cocktail during the celebrations of the Merry Pranksters.
© Ted Streshinsky/Corbis

Page 29: The writer Tom Wolfe, whose essays caught the *Zeitgeist* of the 1960s as well as any other, talks to Rock Scully, the manager of the Grateful Dead, and Jerry Garcia on the corner of Haight and Ashbury streets.
© Ted Streshinsky/Corbis

Page 30: The Jefferson Airplane, epitome of the 1960s San Francisco sound, face the camera.
Michael Ochs Archive/Redferns

Page 31: Grace Slick of the Jefferson Airplane who became the lead vocalist. The band achieved international stardom with 'White Rabbit' and 'Somebody to Love'.
Chuck Boyd/Redferns

Page 32: The City Lights bookstore was, and is, a San Franciscan institution, and the place for the beat poets. Lawrence Ferlinghetti, a leading poet, faces the camera in 1960. With him is Shig, the owner of the shop.
Burt Glinn/Magnum

Page 33: The novelist Ken Kesey, who invented happenings and Be-ins, wears a beaded necklace of Native-American origin.
© Hulton-Deutsch Collection/Corbis

Pages 34–5: Huge crowds attend the Human Be-in on the Polo Fields in Golden Gate Park, 14th January 1967. The message is: 'Let it go. Whatever you do is beautiful.'
California Historical Society, FN32047, 501967, Gene Anthony Collection

Pages 36–7: Janis Joplin went to San Francisco in 1966 and joined Big Brother and the Holding Company as a singer. In 1968 she struck out on her own and became Haight-Ashbury's world celebrity. In 1970 she died from a heroin overdose.
Elliott Landy/Redferns (left); Herb Greene/Redferns (right)

Page 38–9: At the height of her fame Janis Joplin took on the conventional trappings of rock superstardom such as the Porsche, but remained rebellious, vulnerable and lonely.
Redferns

Page 40: A hippie hangout on Haight Street, aptly called Head Quarters. 'Heads' were users of LSD and other narcotics.
Michael Ochs Archive/Redferns

Page 41: The folk singer Joan Baez makes a contribution to a freedom rally in front of Sproul Hall on the Berkeley campus.
© Bettmann/Corbis

Page 42: A San Francisco summer of love poster.
Rex Features

Page 43: A young couple on motorcycles protest against the war in Vietnam.
© Ted Streshinsky/Corbis

Page 44: Window signs at a fast food restaurant in the Haight-Ashbury district during the summer of love.
California Historical Society, FN32050, Gene Anthony Collection

Page 45: Burning candles and batik prints are the main motifs in this Haight-Ashbury apartment.
© Ted Streshinsky/Corbis

Page 46: Hippies pass time in a doorway on Haight Street in the summer of 1967.
Corbis/Bettmann/UPI

Page 47: Kaftaned girls wave joss sticks and wear flowers in their hair in the approved manner.
Michael Ochs Archive/Redferns

Page 48: During the summer of love a bulletin board at the Park Police Station is filled with photographs of young runaways.
© Ted Streshinsky/Corbis

Page 49: The Be-in in Golden Gate Park is over and although many thousands have dispersed, a few stragglers remain, including a couple bent on the injunction Make Love, Not War.
California Historical Society, FN32049, Gene Anthony Collection

Pages 50–1: Joseph Alioto was the mayor of San Francisco in 1968.
© Ted Streshinsky/Corbis

Pages 52–3: The calm of the campus at the University of California at Berkeley is shattered by days of rioting and disturbance in 1968.
Ray Hamilton/Camera Press

Pages 54–5: Police face thousands of students during the Berkeley riots of 1968.
Ray Hamilton/Camera Press

Pages 56–7: Berkeley police in riot gear and gas masks prepare to confront thousands of students bent on insurrection in 1968.
Ray Hamilton/Camera Press

Page 57: A student is arrested at the Berkeley riots.
Black Star/Colorific!

Pages 58–9: Huey Newton, the founder of the Black Panthers talks with his fellow activist Bobby Seale at the party headquarters.
© Ted Streshinsky/Corbis

Page 60: Members of the Black Panther Party, a militant organization, protest on the steps of the Alameda County Court House in 1968 as their leader is tried for killing an Oakland policeman during a street battle.
© Bettmann/Corbis

Page 61: Eldridge Cleaver, author of *Soul on Ice*, was a Black panther and in 1968 the Peace and Freedom party's presidential nominee.
Corbis

Page 62: Mrs Barry Goldwater speaks up for her husband at the Cow Palace Republican Convention in the 1964 race for Presidential nominee.
Eve Arnold/Magnum

Page 63: Standing out from the youthful horde that thronged the Haight-Ashbury neighbourhood is this old-timer, unabashedly declaring his residential rights.
Corbis/Bettmann/UPI

Page 64–5: The party atmosphere of the Republican Convention in 1964, held in the Cow Palace, where Barry Goldwater was voted as presidential nominee.
Topham

Page 65: A woman covered in dollar bills draws attention to fund-raising at the 1964 Republican convention.
Eve Arnold/Magnum

Pages 66–7: Celebrating 'Now Day' in Haight-Ashbury on 17 December 1966, an event that was intended to represent the death of money and the rebirth of a free order.
California Historical Society, FN32048, Gene Anthony Collection

Page 68: A paint crew hangs to the underside of the Golden Gate Bridge in 1965. An area of 10 million square feet has to be painted. It takes four years, and

when it is finished the process has to start all over again.
Hulton Getty

Page 69: The most striking addition to the San Francisco skyline in the 1960s was the Transamerica office building.
Hulton Getty

Pages 70–1: The mayor in 1960, George T Christopher, stands in front of a cable car full of local notables including the proprietor of the first singles bar, a ball player, a model, a nightclub owner, an adman, and, standing on the running board with a cigarette, the columnist Herb Caen.
Slim Aarons/Hulton Getty

Page 72: A couple of San Franciscans relax in the street on a summer evening, taking advantage of the cool air.
Henri Cartier-Bresson/Magnum

Page 73: A craze for face painting in psychedelic designs erupted during the Haight-Ashbury Summer of Love. Here a young woman receives attention.
© Ted Streshinsky/Corbis

Pages 74–5: Downtown office workers speak out against the draft, and call for the end of the Vietnam War in a well-behaved protest.
Michael Ochs Archive/Redferns

Page 76: The Hell's Angel known as Chocolate George in front of the Diggers Shop in Haight-Ashbury. Police arrested him for allowing a girl passenger to stand on the rear seat of his motorcycle, but after the station

was besieged by protestors the charges were dropped.
California Historical Society, FN32046, Gene Anthony Collection

Page 77: A street scene in the Haight-Ashbury district, with an impromptu air interrupting the conversation.
Corbis/Bettmann/UPI

Page 78: A couple face the minister who is wearing psychedelic vestments for an open-air nuptial ceremony.
© Ted Streshinsky/Corbis

Page 79: A striking couple make an impression at the annual Hooker's Ball, organized by a leading campaigner for prostitutes' rights.
Hulton Getty

Page 80: A 17-year-old hippie from Texas, admitting that he was seeking publicity, walks 13 city blocks in the nude. Clothed pedestrians were less bothered by his antics than the police, who removed him from the scene.
Topham

Page 81: A happy couple enjoy their proximity at a peace demo.
Wayne Miller/Magnum

Pages 82–3: The strip of Berkeley wasteland, seized by students and designated the People's Park, was the centre of serious confrontations in 1968. The National Guard was called in after the university authorities lost control.
Ray Hamilton/Camera Press

Pages 84–5: The *San Francisco Chronicle* columnist, Herb Caen, kept his finger on the city's

pulse. Among his many neologisms were 'beatnik' and 'Hashbury'.
California Historical Society, FN32043, Gene Anthony Collection

Pages 86–7: A girl member of the Diggers displays her smile and an unusual form of eye makeup.
California Historical Society, FN32041, Gene Anthony Collection

Page 88: A student campaigns against American involvement in Vietnam, one voice in many.
Hulton Getty

Page 89: A group of hippies perch in a tree in Golden Gate Park, an unconventional resting place frowned upon by the park authorities.
© Ted Streshinsky/Corbis

Pages 90–1: The Artists Liberation Front, assembled by Emmet Grogan (with the beads), meet for an intensive session.
© Lisa Law

Pages 92–3: Lawrence Ferlinghetti, founder of the City Lights bookstore and Timothy Leary, guru of the drop-out generation, share the platform at the Human Be-in.
© Lisa Law

Pages 94–5: Members of a Hell's Angels chapter gather in Golden Gate Park.
© Lisa Law

Page 95: An exhibitionist in a missile-bedecked brasshat's uniform sends up the military. He was known as General Hershey.
© Lisa Law

Pages 96–7: A group of eminent hippies at the Human Be-in, January 1967 in Golden Gate Park. From left are Gary Snyder, Michail McClure, Allen Ginsberg, Meretta Geer and Lenore Kandal.
© Lisa Law

Page 98–9: Crowds in Golden Gate Park attending the Human Be-in disport themselves on the roof an ancient bus.
© Lisa Law

Pages 100–1: Zal Yamoski of the visiting east coast band, the Lovin' Spoonful, hands out autographs to eager fans after their gig at the Cow Palace.
© Lisa Law

Pages 102–3: On a Market Street news stand a headline in the *San Francisco Examiner* proclaims the latest rock 'n' roll outrage. The newspaper maintained an aloof, but observant stance throughout the new permissive era.
© Lisa Law

Page 104: The author Joan Didion takes a stroll around a cellblock of the deserted Alcatraz prison, incorporated into the Golden Gate National Recreation Area, prior to its opening up as a tourist attraction.
© Ted Streshinsky/Corbis

Page 105: The writer John Gregory Dunne, husband of Joan Didion, studies the view of San Francisco during a visit to Alcatraz Island.
© Ted Streshinsky/Corbis

Page 106: Sioux Indians came ashore and seized Alcatraz Island, citing rights under a treaty of 1868 that allowed them to claim 'unoccupied government land'. It took much legal argument and US Marshals to dislodge them.
© Bettmann/Corbis

Page 107: The Native Americans who annexed Alcatraz Island, reclaiming it as their heritage, celebrated Thanksgiving in 1969 in alfresco style in the former prison's recreation area. A restaurant provided the food, ferried to the island by Sausalito yachtsmen.
© Bettmann/Corbis

Page 108: Journalists, having watched the last prisoners transfer from the abandoned penitentiary of Alcatraz to another Federal prison, embark on the ferry from the grim fortress island.
© Ted Streshinsky/Corbis

Page 109: In the Panhandle of Golden Gate Park a group of Diggers, the unofficial welfare organization of the hippies, winds up its dispensation of food and beverages.
Corbis

Pages 110–11: In preparation for the Merry Pranksters' Acid Test Graduation event in October 1966, two of its members decorate their brightly coloured vehicle known as The Bus outside The Warehouse on Harriet Street, south of Market.
© Ted Streshinsky/Corbis

Pages 112–13: Doris Delay in a white jumpsuit jigs with a Hell's Angel during the Acid Test Graduation party at the Warehouse in October 1966. The celebration was organized by Ken Kesey and his Merry Pranksters.
© Ted Streshinsky/Corbis

Page 114: A smooching couple on the dance floor at the Acid Test Graduation celebration.
© Ted Streshinsky/Corbis

Page 115: Page Browning and Doris Delay in the cold light of dawn embrace after the Acid Test Graduation. In the background is Ken Kesey's famous psychedelic bus, parked in front of The Warehouse.
© Ted Streshinsky/Corbis

Page 116: Scott McKenzie, writer and performer of the ballad with the lyric 'If you are going to San Francisco Be Sure to Wear Some Flowers in Your Hair' found he had a huge hit on his hands and a ready-made anthem for the flower-power era.
Harry Goodwin/Redferns

Page 117: A staff photograph of the team behind radio station KMPX in 1967.
© Baron Wolman/Retna

Pages 118–19: Neal Cassady is overshadowed by Gut, a Hell's Angel recruited by the Merry Pranksters. In the background other members decorate the Bus in preparation for the Acid Test Graduation.
© Ted Streshinsky/Corbis

Page 120: A native American daubs a graffiti message on a wall on Alcatraz Island after the temporary annexation.
© Bettmann/Corbis

Page 121: Robert Crumb, who emerged as San Francisco's leading underground comic artist and the creator of Fritz the Cat.
© Baron Wolman/Retna

Pages 122–3: Some older hippies, bemused by the huge numbers choosing to adopt their lifestyle, proclaimed the death of the hippie and with it their rebirth as Free Americans. This rite, carried out on Buena Vista Hill in October 1967, involved the burning of psychedelic posters.
Corbis/Bettman/UPI